PIERS OF THE HEBRIDES AND WESTERN ISLES

Alistair Deayton

AMBERLEY

First published 2012

Amberley Publishing
The Hill, Stroud
Gloucestershire, GL5 4EP

www.amberley-books.com

British Library Cataloguing in Publication Data.
A catalogue record for this book is available from the British Library.

ISBN 978 1 4456 0685 9

Typeset in 10pt on 12pt Sabon.
Typesetting and Origination by Amberley Publishing.
Printed in the UK.

Introduction

The piers, ferry calls and slipways covered in this volume are those of the islands off the West Coast of Scotland from Gigha in the south to Lewis in the north and St Kilda off to the west. Over the years since the introduction of steam navigation, there have been many piers, ferry calls and car ferry slipways, although the building and surfacing of roads in the first half of the twentieth century and consequent withdrawal of cargo steamer services have led to many being abandoned.

The traditional wooden piers, so prevalent in the Firth of Clyde (see the author's *Clyde Coast Piers*, Amberley 2010), were not used in the islands, and many small stone and concrete piers were used; steamers also called at general commercial ports such as Stornoway, and at a number of fishing piers, some built in an expansionist era of the fishing trade in the late eighteenth century by the British Fisheries Society when both towns such as Tobermory and small settlements such as Stein in Skye were founded. Due to the prevalent Atlantic weather and a very wide tidal range, piers could not be built at a number of locations, which had to rely on ferry calls for many years, the small isles of Muck, Rum and Eigg having only had piers built during the past decade.

The development of car ferry services led to the building of a number of car ferry slipways, while the building of bridges in the second half of the twentieth century has meant that the crossings from Kyle of Lochalsh to Kyleakin and at Scalpay were abandoned. The introduction of the roll-on roll-off car ferries on the longer routes led to many piers being transformed by the building of linkspans to access such ferries at any state of the tide.

Over the years permanent inhabitants have left some of the islands, including Tanera in the Summer Isles in 1881, St Kilda in 1930 and Soay in 1953.

The roll-on roll-off ferries had a huge impact on the puffer trade; these small cargo vessels, which had previously run onto the beach to discharge their cargoes, were now redundant.

The entire area covered in this volume relied on vast knowledge, a lot passed on through several generations of the same families. The masters of the twenty-first-century ships continue this great tradition.

The illustrations in this volume show most of the piers and slipways over the years, the vast majority served by the steamers and motor vessels of David MacBrayne Ltd, since 1973 Caledonian MacBrayne. (For more details of these steamers see *A MacBrayne Album* by the author and Iain Quinn, Amberley 2009).

Many of the ferry calls and smaller piers predate the era of popular photography and some were very remote and difficult to get to. In this respect it is essential to pay tribute to the late Jim Aikman Smith, a former secretary of the West Highland Steamer Club, whose indefatigable efforts in photographing unusual vessels at unusual ports of call have been unsurpassed. He was even arrested by the naval authorities at one point when landing on a small island which had a military installation on it, which was deemed to be an area important to national security, for a photo of a ferry making an unusual call there

Acknowledgements

My thanks are due as always to Iain Quinn for help with the text and for the supply of some photographs. Thanks are also due to several giants no longer with us: C. L. D. Duckworth and Graham E. Langmuir for gathering the historical material on steamer service in the West Highlands in *West Highland Steamers*, originally published in 1935; Jim Aikman Smith for his mammoth task in photographing ships and ferries from the 1960s until his untimely death in 1995; and Hamish Stewart in recording a more recent era.

Thanks are also due to Ian Somerville, Fraser MacHaffie, Neil King, Fraser Pettigrew, Peter Reid, Lawrence MacDuff, Alasdair Aitken and Robert Beale.

Chapter 1

Piers of the Southern Inner Hebrides (Islay, Jura, etc.)

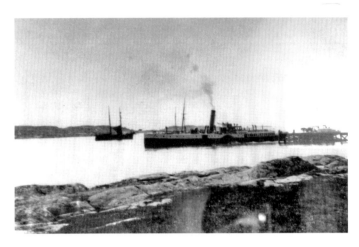

In the days before the car ferry, Gigha was served by two calling-points, a ferry landing at the north of the island for the Port Askaig steamer, and a steamer pier at the south, in the shelter of the islet of Gigalum, for the Port Ellen steamer. The paddle steamer *Pioneer* is seen here at the pier, which dates from 1895 in its present form.

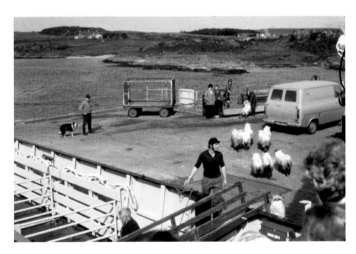

From the withdrawal of the hoist-loaded service by *Arran* on 31 December 1972 until the arrival of *Pioneer* on 14 August 1974, Gigha was served only by the small, council-owned passenger ferry to Tayinloan. Sheep are seen here being loaded from Gigha in 1974 onto *Pioneer*.

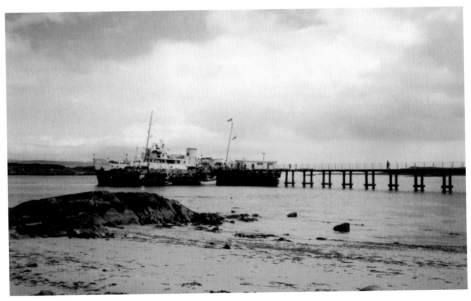

Gigha Pier has continued to see occasional use, as here on 30 April 1994 by MV *Balmoral*. Western Ferries built a linkspan at the north end of the island in September 1970, but it was destroyed by a gale in January 1972 and not rebuilt.

The present ferry service to the island, from Kennacraig to the south pier, was introduced on 15 February 1979 by *Bruernish*, with cars being unloaded by crane there. When the slipways at Tayinloan and Ardminish were ready on 11 November 1980, the ferry from Tayinloan to the new Gigha slipway was inaugurated by *Coll*, *Bruernish* being away for overhaul. The slipway it serves is centrally located in the island, not far from the Gigha Hotel, and *Loch Ranza* is seen there on 31 May 2011.

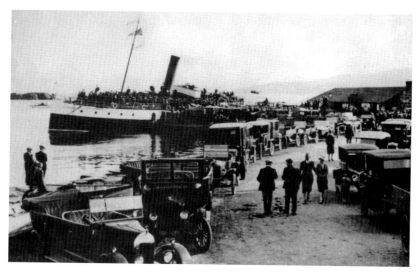

Port Ellen has had steamer calls since early 1842, when *Toward Castle* sailed from Glasgow, also making a trip from West Loch Tarbet connecting with another of the Castle Company's steamers sailing to Tarbet, on the other side of the isthmus. In 1846, *Modern Athens* offered two sailings a week from West Loch Tarbert and one from Glasgow. The services were maintained by local owners until they were taken over in 1875 by David Hutcheson & Co., which became David MacBrayne four years later. It was not until 1905 that a dedicated Islay steamer was built in the form of *Pioneer*, seen here at Port Ellen with a large number of motorcars and charabancs assembled to meet her.

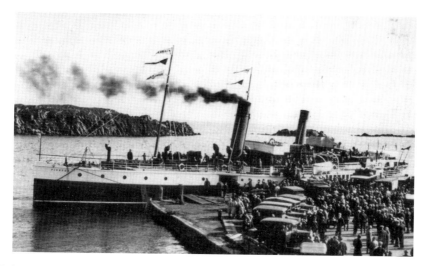

A daily service from West Loch Tarbert to Islay was inaugurated in 1878 by *Glencoe*, although in the 1880s Port Askaig was only served once weekly, and in the 1890s twice weekly. From 1879 to 1881, the screw steamer *Lochiel* replaced *Glencoe*, and from 1885 to 1890 the screw steamer *Fingal* was on the route. In 1905, the paddle steamer *Pioneer* was built and she is seen here disembarking passengers at Port Ellen on a very busy Glasgow Fair Saturday, probably in the 1920s, with her sailing duplicated by *Mountaineer*, moored outside her. By the 1930s, Port Askaig and Port Ellen were serviced on alternate weekdays, with no Sunday sailings until much later.

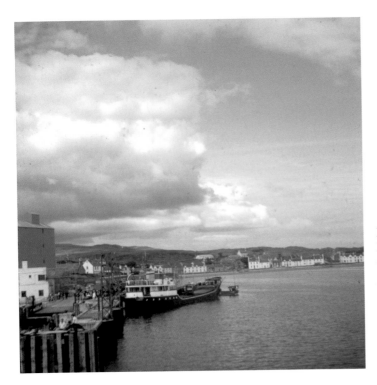

In the 1930s MacBrayne's built one of the white art-deco pier buildings, like those at Fort William and Tobermory, at Port Ellen, seen here to the left in this 1975 view with an Everard coaster berthed at the pier.

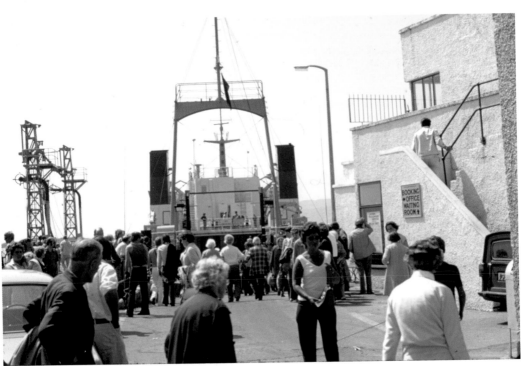

In 1970, a car ferry service was started with *Arran*, and in 1974 the car ferry *Pioneer* took over, a linkspan having been built in the previous year, as seen here in 1977.

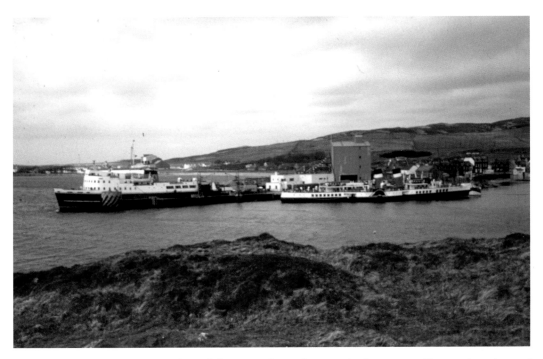

Port Ellen has been a regular call for *Waverley* on her positioning run to Oban each spring and she is seen there with car ferry *Glen Sannox* in 1983. Her initial call there in 1981 was the first call there by a paddle steamer since the war.

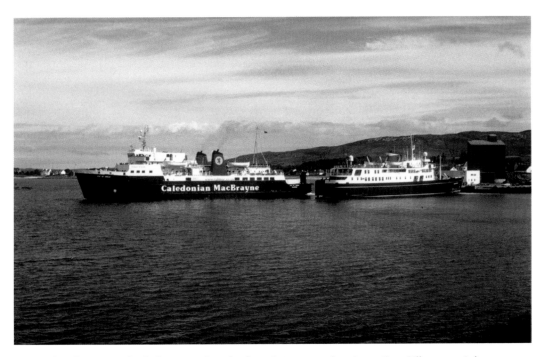

Isle of Arran at the linkspan and *Hebridean Princess* at the pier at Port Ellen on 9 July 2004.

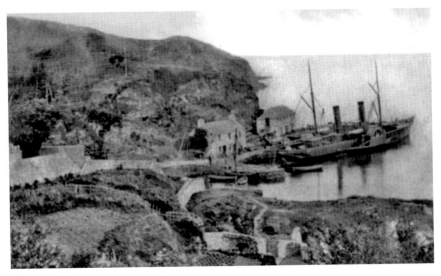

The first steamer service advertised from West Loch Tarbert to Port Askaig was by *Maid of Islay* in 1826, replaced by *Maid of Islay No 2* two years later, when her predecessor was renamed *Maid of Islay No 1* and ran from Glasgow to Tarbert in the summer months. Various locally-owned steamers continued the services from Glasgow and from West Loch Tarbert for almost fifty years until David Hutcheson & Co. took over the service in 1875, along with the paddle steamer *Islay* of 1867, seen here at Port Askaig, which served the Glasgow to Islay service, sailing from Glasgow on Mondays and Thursdays, with the Monday sailing to a ferry call at Port Charlotte and Port Ellen, and the Thursday to Port Ellen and Port Askaig with a ferry call at Feolin for Jura traffic.

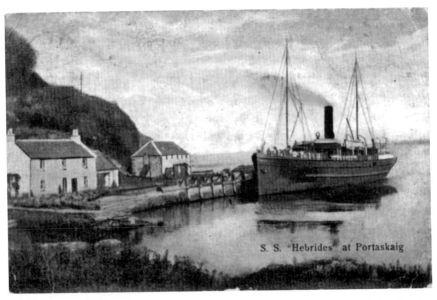

S. S. "Hebrides" at Portaskaig

McCallum Orme's *Hebrides* also called at Port Askaig en route to Skye and the Outer Isles, as seen in this postcard posted there in 1911, the writer saying, 'We are expecting a rough passage round Mull'. This is one of a series sold on board the steamer.

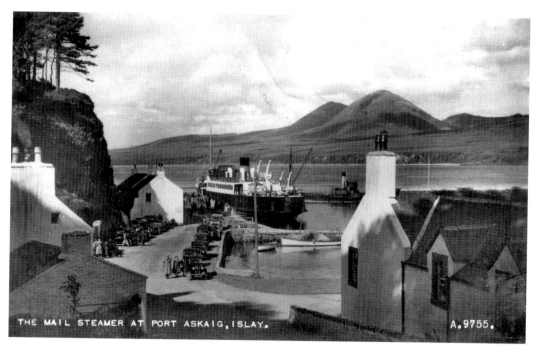

THE MAIL STEAMER AT PORT ASKAIG, ISLAY. A.9755.

In 1940, *Pioneer* was replaced by the motor vessel *Lochiel*, seen here in a postcard view at Port Askaig with a puffer in the background.

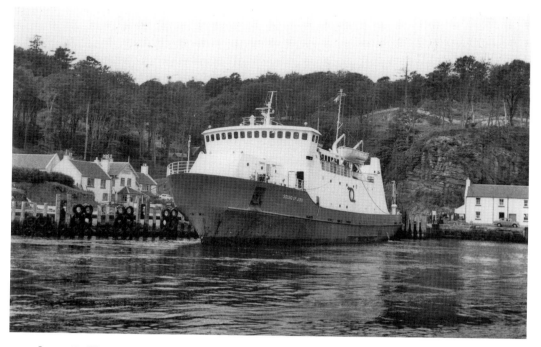

In 1968, Western Ferries commenced a car ferry service from Kennacraig to Port Askaig with *Sound of Islay*, replaced a couple of years later by *Sound of Jura*, seen here at Port Askaig.

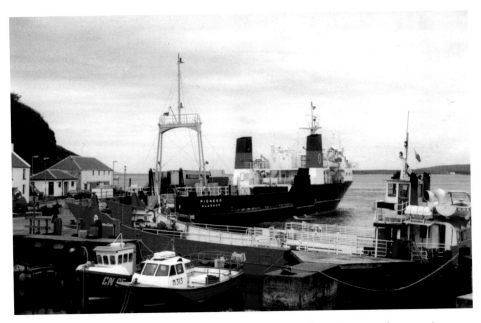

MacBrayne introduced the hoist-loading former Clyde car ferry *Arran* on the route in 1970, replacing *Lochiel*. The car ferry *Pioneer*, introduced in 1974, is seen here at Port Askaig with Western Ferries Jura ferry *Sound of Gigha* in the foreground.

Iona took the route over in 1979 and is seen here berthed at Port Askaig in 1988. Western Ferries ceased operations from Kennacraig to Islay in 1981.

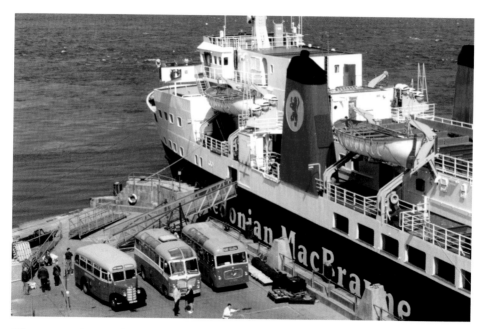

Claymore took over the Islay service in 1990 and was replaced by *Isle of Arran* in 1993, seen here at Port Askaig with three preserved MacBrayne buses on the quayside. *Hebridean Isles* took over the route in 2001, but *Isle of Arran* has continued as a second ship on the route.

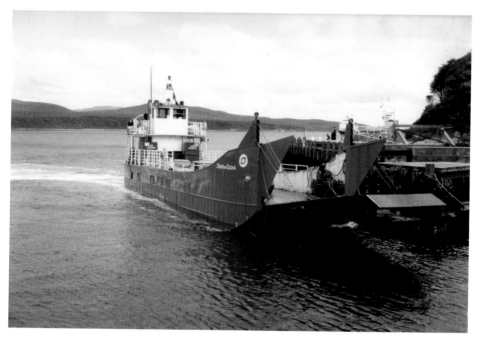

Western Ferries introduced a service across the Sound of Jura to Feolin by the landing-craft type ferry *Sound of Gigha*, seen here at Port Askaig, in 1969.

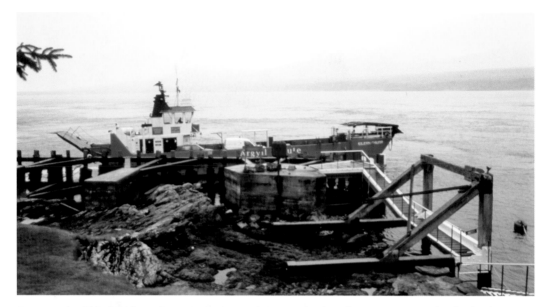

In 1998 the Port Askaig to Jura service was taken over by Argyll & Bute Council, who built a new ferry, *Eilean Dhiura*, for the service. She, unusually, has both bow and stern ramps, and is seen here at Port Askaig in 2003.

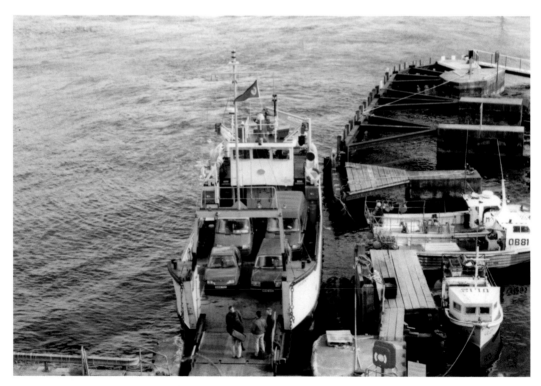

On occasion, *Eilean Dhiura* has been relieved when on overhaul by a Caledonian MacBrayne Island-class ferry, here *Bruernish*, showing the berthing facilities installed in 1970 for *Sound of Jura*.

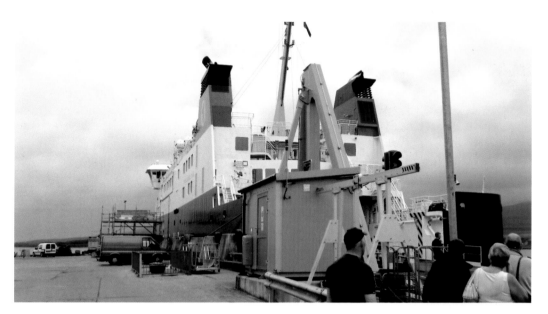

In 2011, the new Polish-built ferry *Finlaggan* took over the Kennacraig to Islay services, and is seen here at Port Askaig on 14 July 2011.

A number of other piers on Islay, serving whisky distilleries, were served by MacBrayne cargo vessels. Caol Ila, seen here in a drawing with the 1867 *Islay* berthed, was not far north of Port Askaig. The steamers brought coal to fire the distilling vats, and wood, for the barrels, and took out full barrels of whisky to the bottling plants in the central belt.

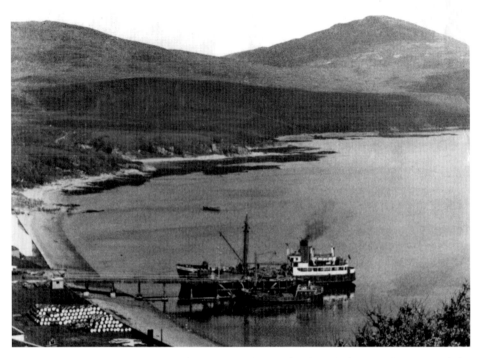

Bonahaven, also known as Buinnahabhain, to the north of Caol Ila, is at the north of the Sound of Jura, and MacBrayne's last steam cargo ship, *Loch Frisa*, is seen there on 16 June 1962. Note the stack of barrels to the left of the pier.

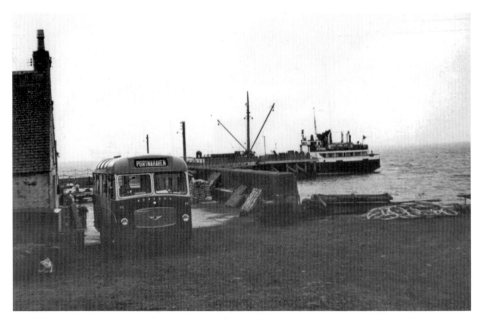

The MacBrayne cargo steamer *Lochbroom* is seen at Bruichladdich on 3 May 1965 with a MacBrayne bus waiting for passengers, en route to Portnahaven, at the end of the road.

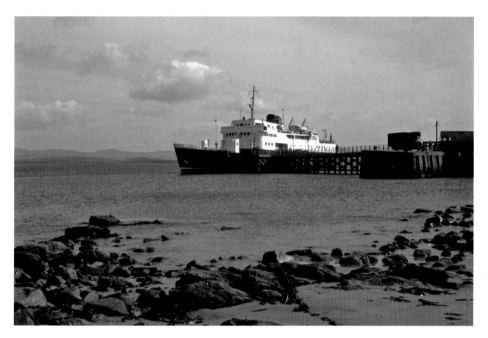

Bruichladdich had a livestock call by the car ferry *Columba*, carrying a party of West Highland Steamer Club members, in September 1978.

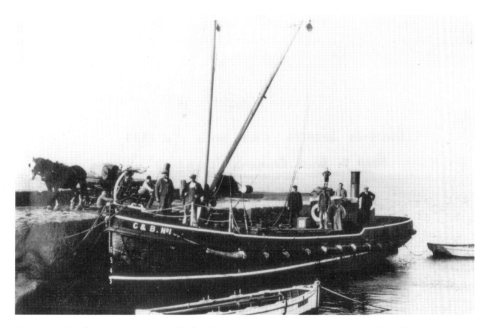

Bowmore harbour was too small for the cargo steamers to berth and MacBrayne bought the steam Thames cargo lighter *C & B No. 1* in 1928 from Crosse and Blackwell to serve as a tender there, replacing a sailing vessel. She was renamed *Lochgorm* in 1930 and *Iona* in 1936 and was replaced in the following year by road transport.

Port Charlotte was a ferry call by *Islay* of 1867 in the 1880s.

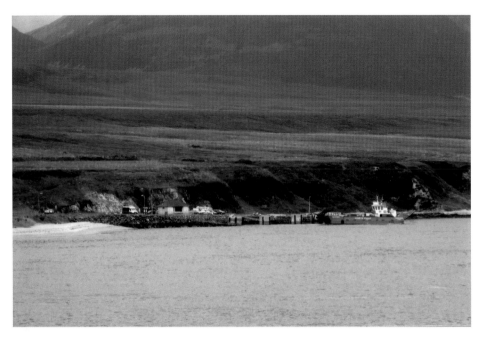

The slipway at Feolin, at the Jura end of the ferry crossing from Port Askaig, with *Eilean Dhiura* departing on 14 July 2011.

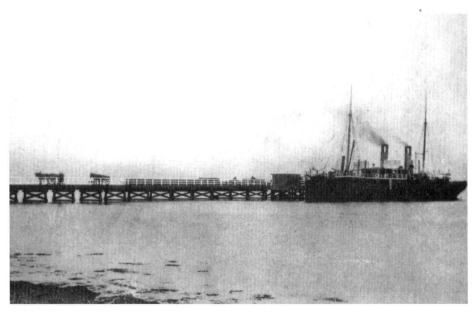

The main pier on Jura was at Craighouse, where the third *Islay*, formerly *Princess Louise* on the Stranraer–Larne service, is seen in the 1890s. The pier continued in use until the introduction of the car ferry service from Port Askaig to Feolin in 1969. The MacBrayne cargo steamers also called at Ardlussa, further north on Jura, until about 1950.

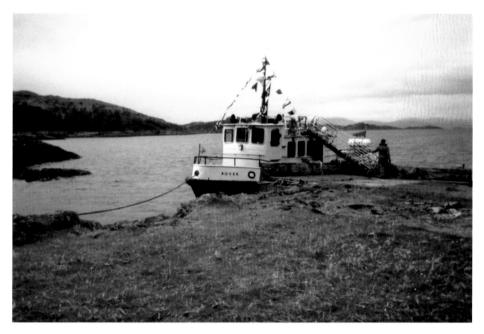

The island of Scarba was never big enough to have a steamer service. On 1 May 2010, Clyde Marine's *Rover* called on a special cruise that had come through the Crinan Canal earlier that day.

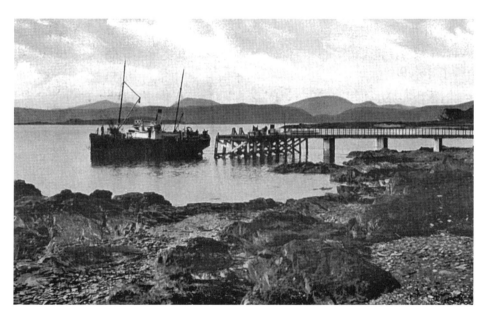

Blackmillbay on Luing was the first northbound pier call after Crinan for the Oban steamer, although there was a ferry call at Craignish until the early twentieth century, and the cargo steamers called at Ardfern in the 1930s. The dumpy *Handa*, known as 'MacBrayne's Gladstone Bag' is seen here off Blackmillbay Pier prior to 1914.

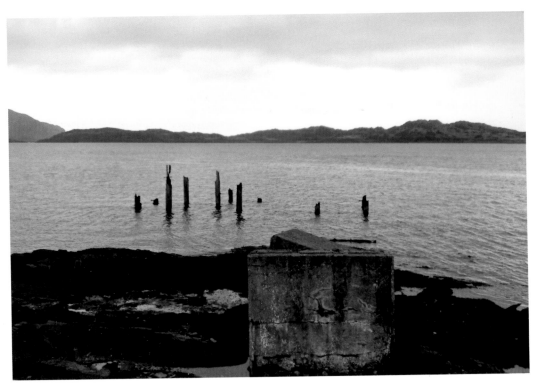

The remains of Blackmillbay Pier in 2010.

On the south-eastern side of Luing is
Toberonochy, advertised as a historic former
slate harbour.

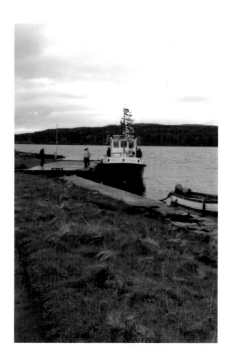

Toberonochy was never a regular port of call by MacBrayne steamers. Clyde Marine's *Rover* is seen there on 1 May 2010 on a unique passenger call.

Luing's access to the mainland is by the Cuan Ferry, connecting South Cuan on Luing with North Cuan on the island of Seil, which is connected to the mainland by the famous 'Bridge over the Atlantic'. *Belnahua*, seen here at North Cuan, has been the council-owned car ferry here since her construction in 1972. The council-owned car ferr service has been provided here since 1954.

The final call northwards towards Oban was at Easdale. Easdale Pier is actually on the island of Seil, in the village of Ellanbeich, and is in the middle distance on this Edwardian postcard view of Easdale.

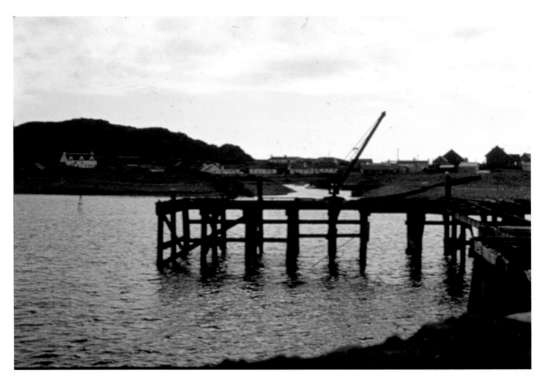

The remains of Easdale Pier. An open boat, owned by Argyll & Bute Council, makes the ferry crossing from an adjacent slipway to a slipway on Easdale Island.

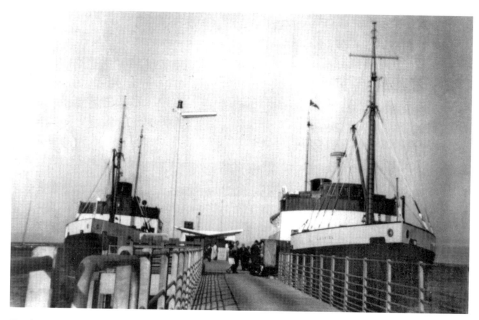

Until 1948 Colonsay was served by *Hebrides* and *Dunara Castle* of McCallum Orme, but following their take over by MacBrayne on 1 January that year, it was included in the MacBrayne network. From 1949 it was served by *Lochiel* as an extension of her sailings to Askaig once or twice a week, with the call being by ferry until the pier at Scalasaig was built and opened in January 1965. Here, on 30 June 1965, both *Lochnevis*, left, and *Lochiel*, right, are berthed at the pier, the former having just arrived from Oban to take over the mail service and the latter about to return to West Loch Tarbert to commence a new car ferry service to Port Askaig.

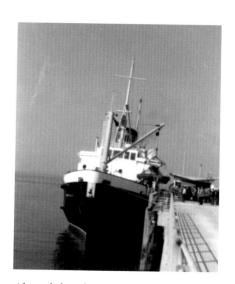 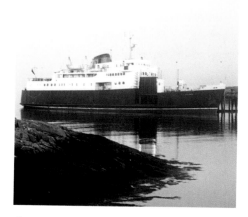

Above left: *Claymore* served Colonsay, where she is seen here, in 1974 and 1975.

Above right: In 1975, *Columba* started a car ferry service from Oban to Colonsay, where she is seen here, and in 1988 a linkspan was installed.

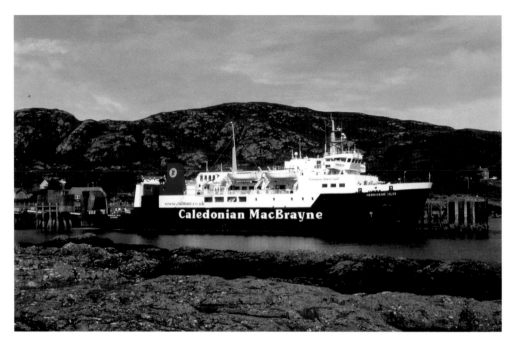

In 1989, a weekly return service on Wednesdays in the summer timetable commenced from Kennacraig to Oban via Port Askaig and Colonsay. A similar winter service was started in the winter 2011/12 timetable. *Hebridean Isles* is seen here at Colonsay in September 2006 while en route from Oban to Kennacraig.

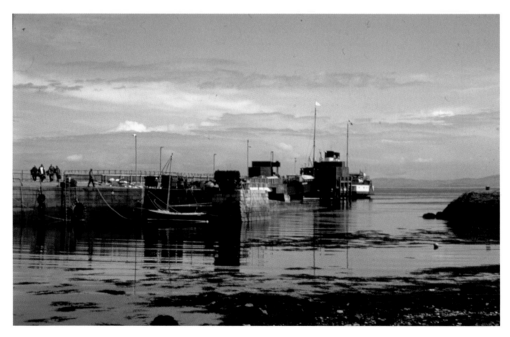

Waverley is seen here at Colonsay pier on 12 May 2007, the first ever visit there by a paddle steamer, showing the linkspan.

Chapter 2

Piers of the Central Inner Hebrides (Mull, Tiree, etc.)

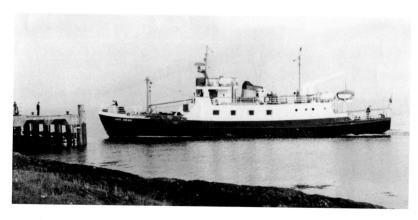

The pier at Achnacroish in Lismore has been served by steamer since the earliest days of steam navigation, and was for many years a call on the Oban–Fort William service. From 1947, a dedicated service to the island from Oban was started by *Lochnell*, replaced in 1964 by *Loch Toscaig*. On occasion *Loch Arkaig* served the route during overhaul periods of the regular vessel, as seen here on 4 October 1972.

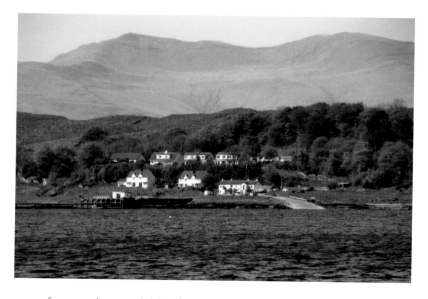

In 1974, a car ferry service was initiated to Lismore, serving a ramp to the north of the pier, although initially cars were discharged onto the beach here.

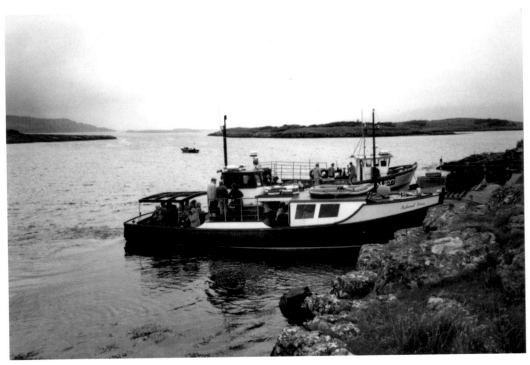

The small jetty at Duart Castle on Mull is served by excursion boats from Oban, with *Island Lass* seen there on 20 July 1973.

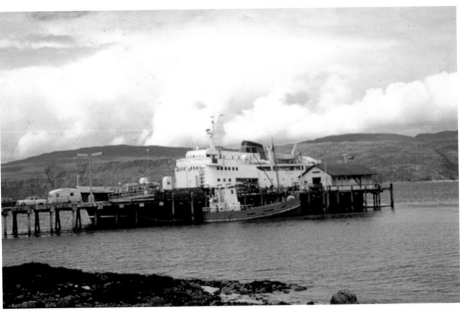

Craignure was served by a ferry call on the Sound of Mull mail service until the pier was opened on 5 December 1963. On 30 July 1964, *Columba* started the Oban–Craignure–Lochaline car ferry service. She is seen here at Craignure in 1967.

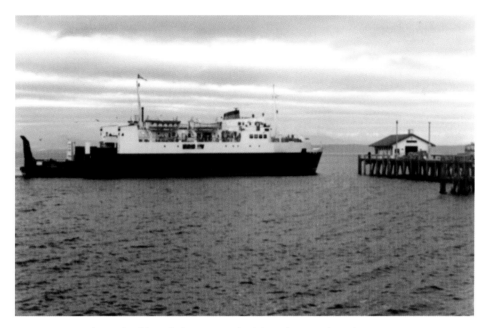

Iona, prior to her rebuild and the removal of her dummy funnel, arriving at Craignure *c.* 1973. In 1973 a linkspan was installed at Craignure, enabling bow and stern loading, and the Oban–Lochaline service was cut back to Craignure on the opening of the Lochaline to Fishnish crossing.

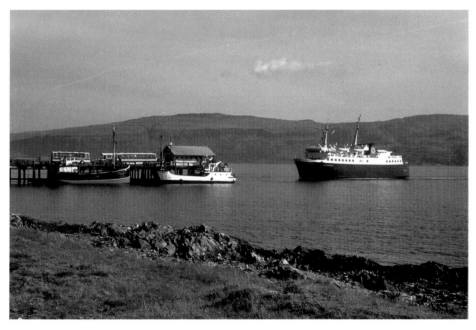

From 1976 to 1987, *Caledonia* served the Oban to Craignure service in the summer months. She is seen here approaching the pier with the Island-class ferry *Kilbrannan* and the puffer *Marsa* at the pier, and several buses on the pier awaiting tour groups en route to Iona.

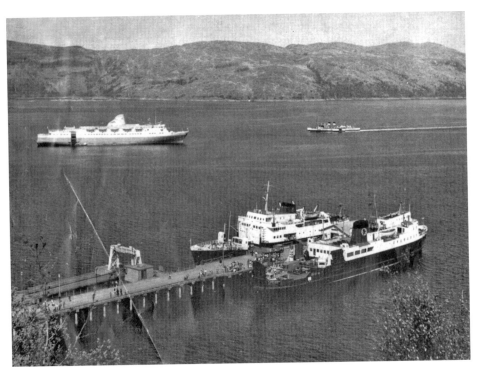

Craignure on 8 May 1984, when the linkspan was closed for repairs and a two-ship car ferry service was in operation. *Glen Sannox* is offloading and *Columba* about to depart for Oban. The cruise ship *Black Prince*, on a National Trust for Scotland cruise, is anchored off and *Waverley* is passing.

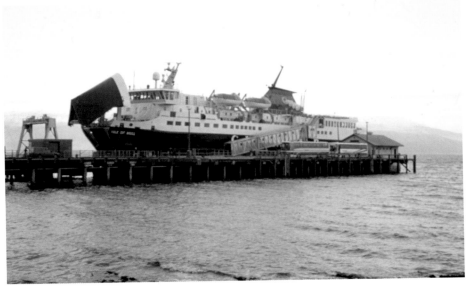

In 1988, the purpose-built ferry *Isle of Mull* took over the Craignure service, and still remains there. She is seen here at Craignure in 1990.

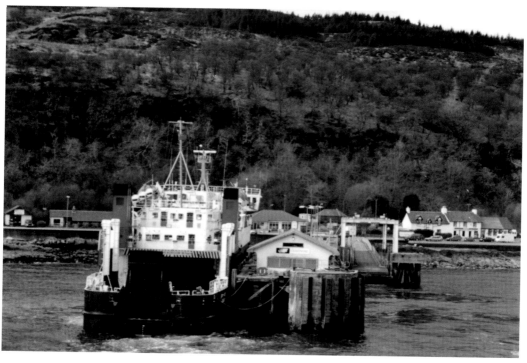

Lord of the Isles at the lay-by berth at Craignure, showing the linkspan on the other side of the pier.

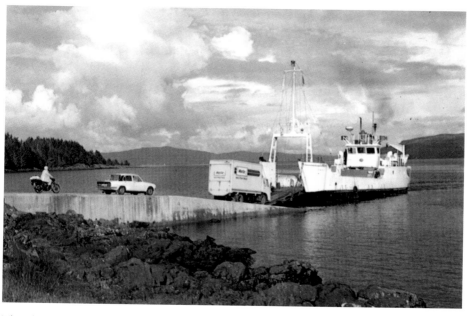

The slipway at Fishnish was opened in 1973 when a back-door crossing to Mull was started from Lochaline with the Island-class car ferry *Morvern*. Other members of her class followed her, including *Coll*, seen here in a postcard view.

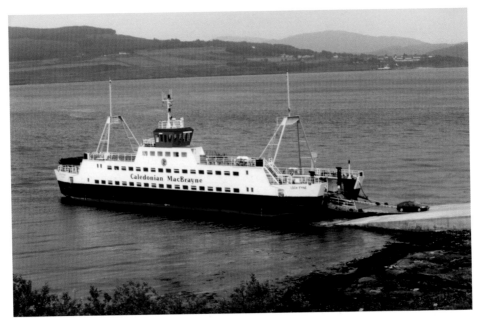

Loch Linnhe came onto the service in 1986, followed soon by *Isle of Cumbrae*. In 1997, *Loch Aliann* arrived, but only lasted three weeks until she broke down, being briefly replaced by *Loch Dunvegan* and then by her sister, today's regular ferry *Loch Fyne*, seen here at Fishnish, both of which had been made redundant two years previously by the opening of the Skye Bridge.

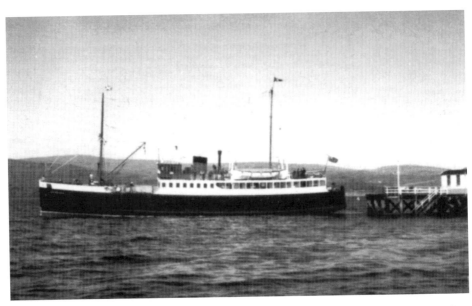

Salen Pier was a regular call on the Sound of Mull mail run by *Lochinvar*. In the late nineteenth century it was also used by the Staffa and Iona steamer *Grenadier*, by *Gael* en route to Gairloch, and by the Glasgow to Stornoway steamers. *Lochearn* replaced *Lochinvar* in 1955 and is seen here leaving Salen.

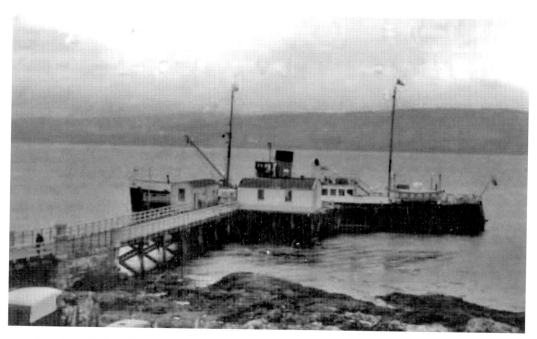

The Sound of Mull mail service was closed by *Lochnevis* in spring 1964, and she is seen here at Salen on 8 April 1964.

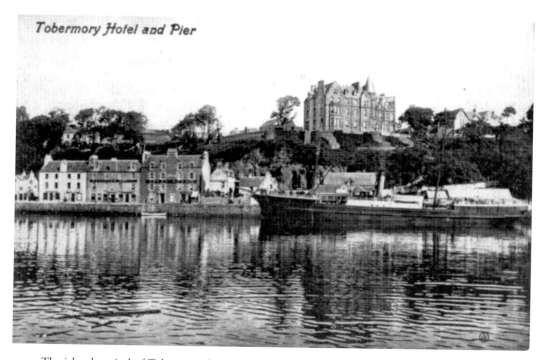

Tobermory Hotel and Pier

The island capital of Tobermory has long been a port of call for ships passing through the Sound of Mull. *Flowerdale* is at the pier in this postcard view with the newly-built Western Isles Hotel prominent above the pier.

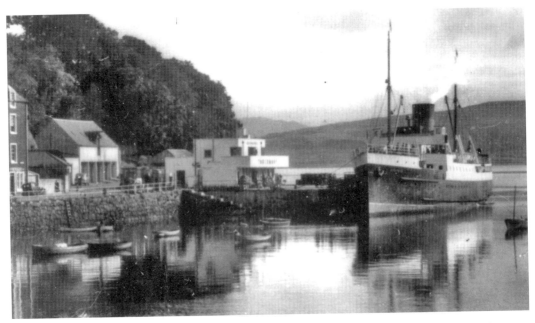

Lochness at Tobermory in the late 1940s, after she had been replaced by *Loch Seaforth* on the Stornoway mail service. The Art-Deco pier buildings, similar to those at Fort William and Port Ellen, can be seen here.

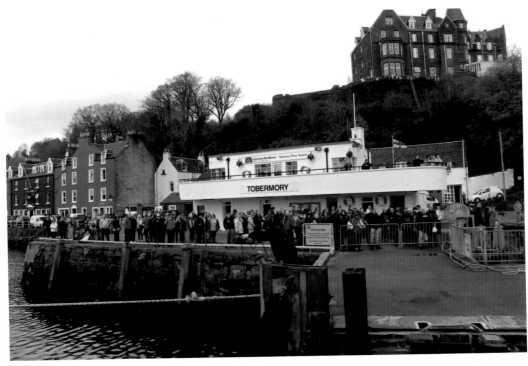

The pier buildings survive, as does the Western Isles Hotel, and both are seen here in 2011 from *Waverley*, en route to Rum.

King George V would often give time ashore at Tobermory when weather prevented landing at Staffa or Iona. She is seen here from the grounds of the Western Isles Hotel in 1969.

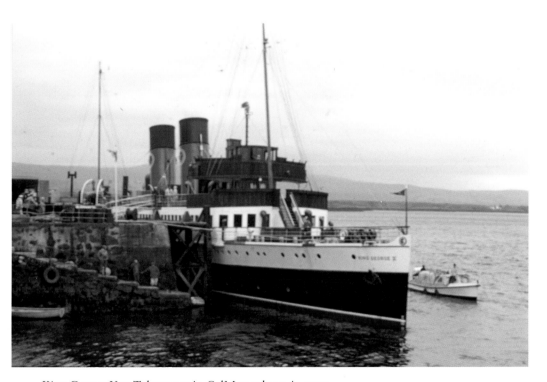

King George V at Tobermory in CalMac colours in 1973.

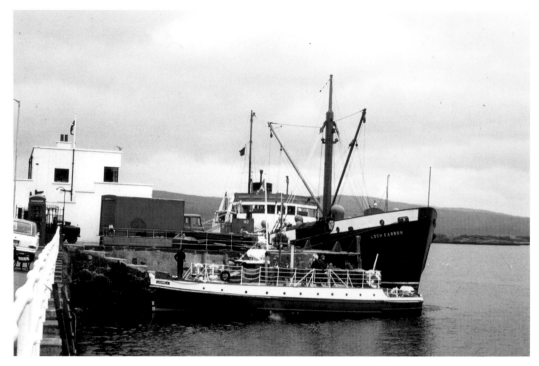

Tobermory was also a call for MacBrayne cargo steamers. *Loch Carron* is seen there in 1970 with *Lochnell*.

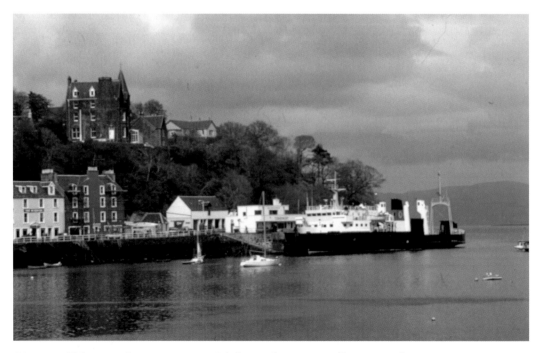

Pioneer at Tobermory in 1983 on a special charter from Fort William to Mallaig.

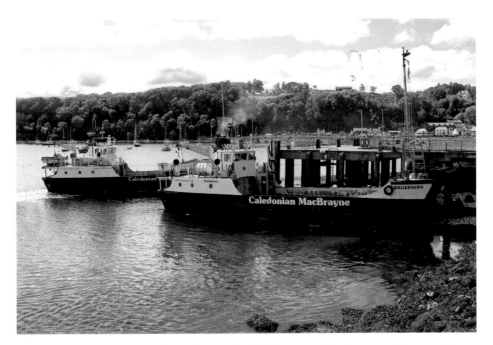

In 1988, a slipway was built to the north of Tobermory Pier for a car ferry service to Mingary, initially maintained by an Island-class ferry. Stand-by vessel *Bruernish* is seen here berthed at the pier, while *Raasay* arrives for her overnight berth.

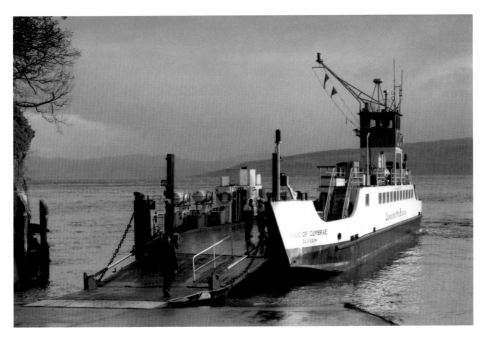

Isle of Cumbrae has been used relieving on the route, and is seen here at Tobermory on 13 November 2007, while regular winter ferry *Raasay* was relieving on the Port Askaig to Feolin service.

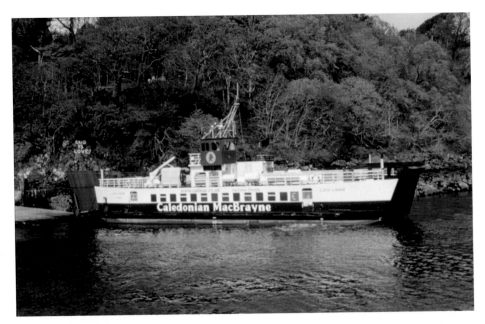

The regular ferry *Loch Linnhe* departing Tobermory in May 2005. It has always been a mystery how somebody could reach that rock to paint the words 'God is Love' on it.

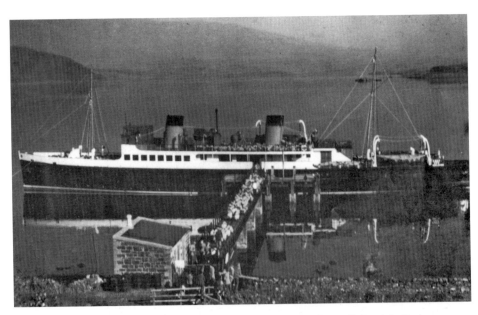

Croggan Pier, at the entrance to Loch Spelve, was a regular call for MacBrayne cargo steamers, with *Dirk* calling thrice weekly before 1914 and *Brenda* weekly in the 1920s. These MacBrayne cargo steamers also made calls at Calgary on the west of Mull and Tavool and Tiroran on the north and Pennyghael on the south of Loch Scridain. Croggan Pier was later used occasionally for loading sheep for the autumn sales, as on this occasion with *Lochfyne* in the mid-1950s. The pier and the 7 miles of road serving it were built in 1896 as part of a plan for an overland route to Iona that never got off the ground.

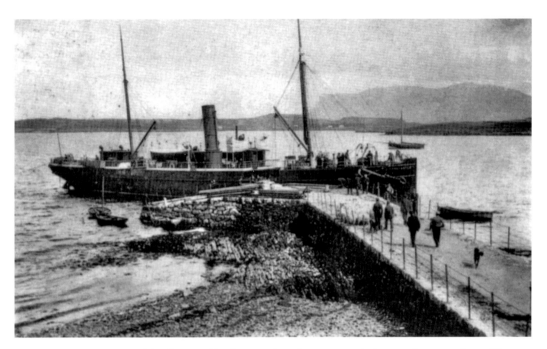

Bunessan was served by *Dunara Castle*, seen there in a postcard view, on her route from Glasgow to western Skye and the Western Isles right up to her demise in 1948. It was also the final call on a thrice-weekly service from Oban by *Dirk* via Tobermory, Kilchoan, Coll and Tiree up until 1914.

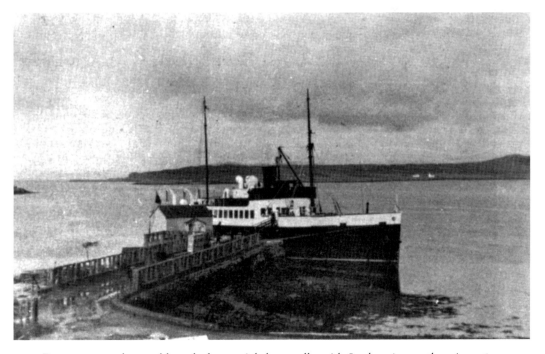

Bunessan was also used latterly for special sheep calls, with *Lochnevis* seen there in 1965.

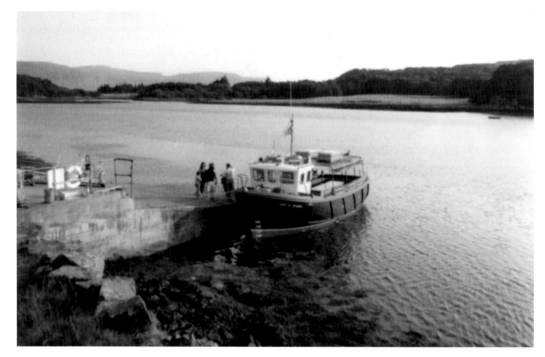

The small island of Ulva, along with the neighbouring island of Gometra, was a MacBrayne cargo steamer call prior to 1950, with *Lochshiel* advertised to call there in 1948. In recent years it has been the destination of excursion boats from Ulva Ferry on Mull, and *Laird of Staffa* is seen thee in the early 1970s.

These sailings also go to the Treshnish Isles, and *Fingal of Staffa* is seen there at Lunga.

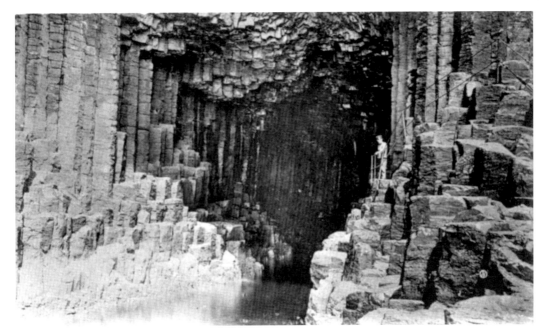

The basalt rock formations and caves of Staffa have been a Mecca for tourists since the visit of Sir Joseph Banks in 1772, with Felix Mendelssohn visiting in 1829 on the steamer *Maid of Morvern* and subsequently writing the *Hebrides Overture*, also known as *Fingal's Cave*. From not long after that steamers ran regularly from Oban round Mull, with calls at Staffa and Iona, with *Dolphin* (1844), *Pioneer* (1844), *Queen of Beauty* from Fort William, and *Chevalier* (1866).

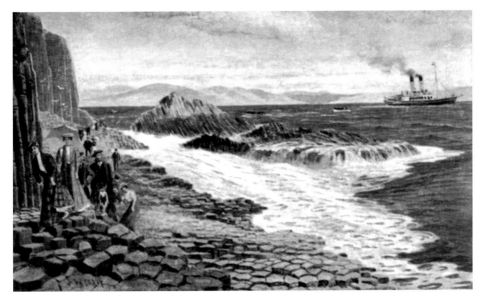

Passengers landing at Staffa from *Grenadier*, which was on the service from 1885 until 1927, in a postcard view from The Royal Route series.

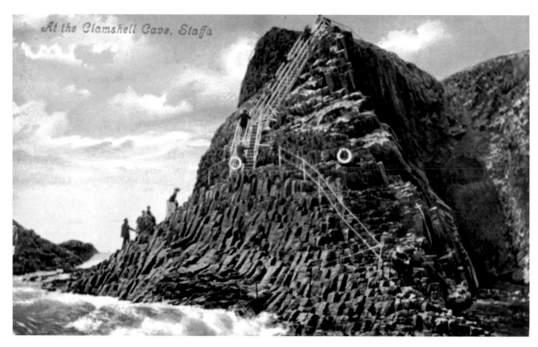

At the Clamshell Cave, Staffa

Landings were also made at the Clamshell Cave, seen here in an Edwardian postcard, with the steps up to the top visible.

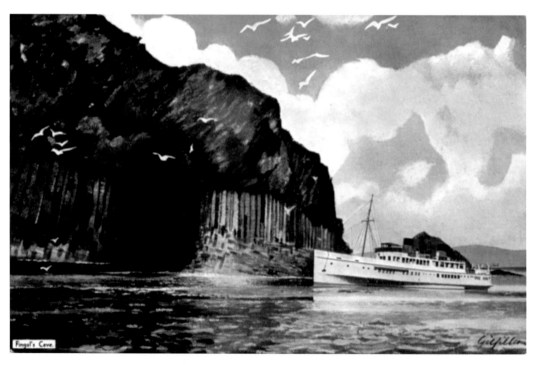

Fingal's Cave.

From 1931 to 1935 *Lochfyne* was on the Staffa and Iona run, and is seen here in one of a series of art postcards issued at that time, showing her in the short-lived grey hull colour scheme.

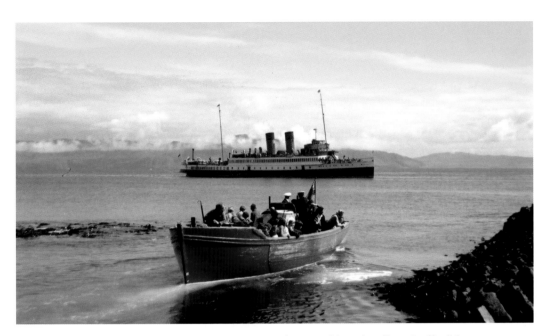

From 1936 until 1974 *King George V* was on the run, although calls at Staffa did not start after the war until 1950 and ceased after the landing stage was damaged in 1967. The ferries normally came up from Iona for this purpose and sometimes were unable to make the journey because of weather. After the withdrawal of *King George V* in 1974, *Columba* offered a Staffa and Iona cruise, passing close to Fingal's Cave, until 1988, but only twice a week.

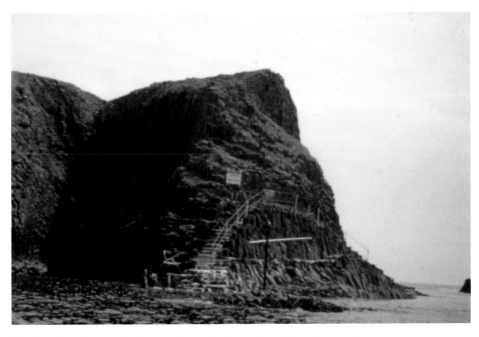

The landing place at Staffa, seen from the ferry from *King George V c.* 1961.

The islet known as the Herdsman, with passengers off *King George V* to the far left on the pathway to Fingal's Cave, on the same occasion.

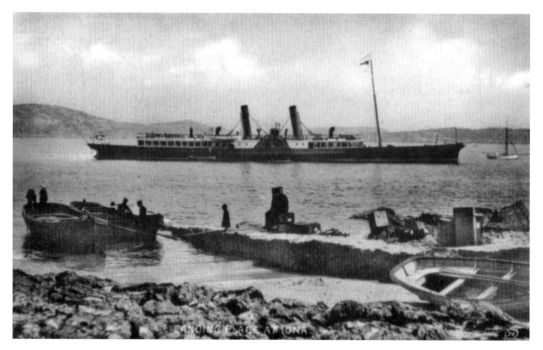

Grenadier at Iona in her original condition before receiving larger funnels in 1903.

Disembarking from *King George V* into one
of the MacBrayne-owned red boats at Iona in
1969.

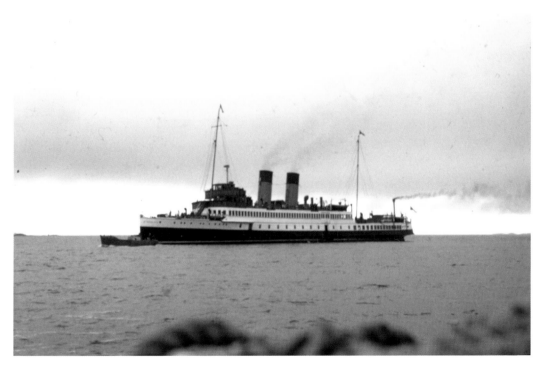

King George V anchored in the Sound of Iona, from one of the red boats, in 1969.

King George V in the sound of Iona, 1969, with the famous white sands of the island in the foreground.

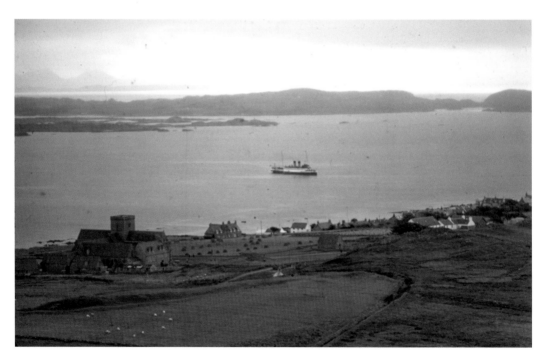

Iona Abbey, with *King George V* anchored in the sound, from part way up Dun I, in 1969.

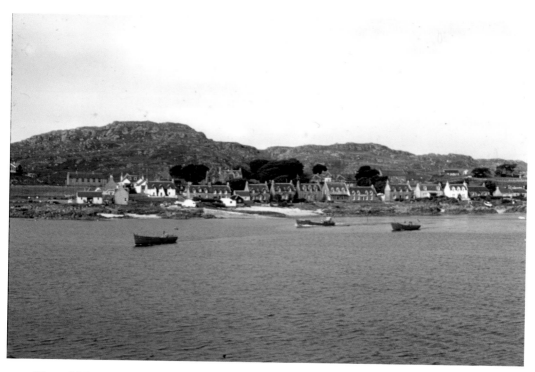

The red MacBrayne ferry boats also ran a passenger service to Fionnphort, and three are seen off Iona village in 1969.

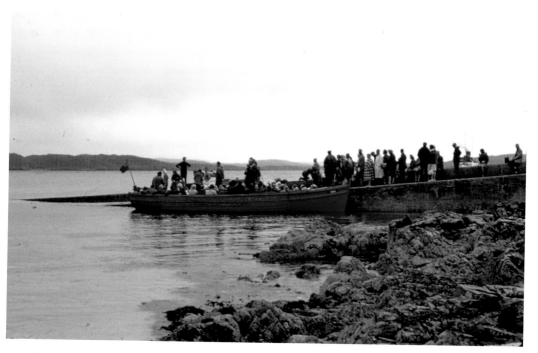

Passenger queuing to get the ferry *Iona* back to *King George V* on the same occasion in 1969.

Since 1982 *Waverley* has made sailings to Iona in most years, normally at the early May holiday weekend. Passengers are disembarking here from her in 1982 into the Island-class car ferry *Morvern*, which was on the Fionnphort to Iona service at that time, and had had seats fitted on the car deck.

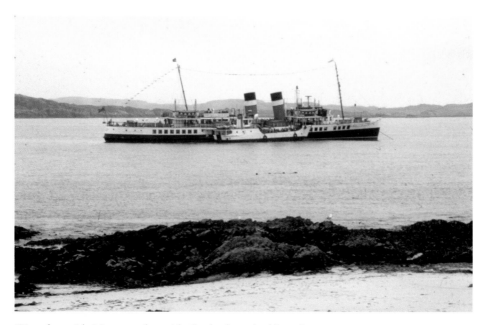

Waverley, with *Morvern* alongside, in the Sound of Iona in 1982.

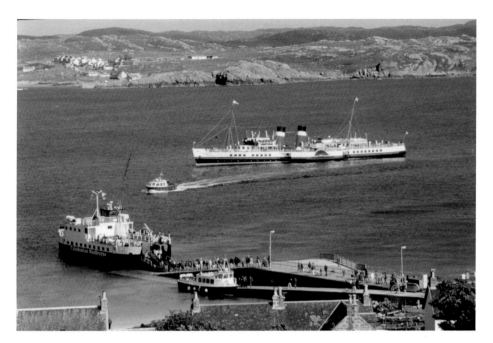

Waverley is normally tendered nowadays by the excursion boats of Gordon Grant. Here the Caledonian MacBrayne car ferry *Lochbuie* is at the slip on the Fionnphort service, *Ullin of Staffa* is alongside the slipway and *Laird of Staffa* is on her way back from the paddler.

In 1979, Caledonian MacBrayne opened a service from Fionnphort to Iona with the Island-class car ferry *Morvern*. Only residents' cars were carried, and small commercial vehicles serving the island. She is seen here at the Iona slipway in 1982, disembarking passengers from *Waverley*.

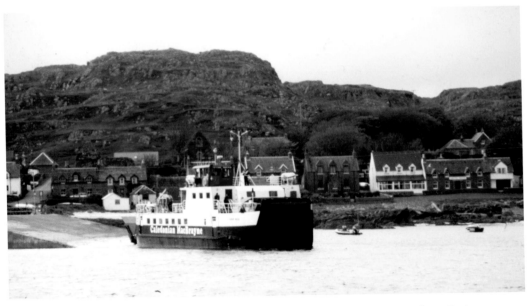

From 1986, a second Island-class car ferry was needed at Iona as coach passengers from Craignure increased with the introduction of the 1,000-passenger *Isle of Mull* on the Oban to Craignure service. In 1992, the new ferry *Lochbuie*, illustrated here, was built. Similar to the Loch-class car ferries, she had increased passenger space on the car deck giving a passenger capacity of 250 and is seen here just off the Iona slipway.

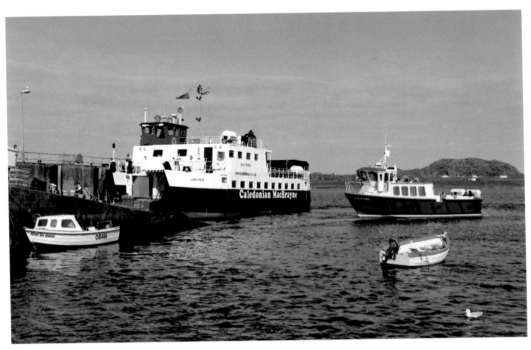

Lochbuie at the Fionnphort slipway on 28 August 2006, with *Ullin of Staffa* arriving.
Prior to 1914, the MacBrayne round-Mull steamer made a call at Carsaig on the south of Mull

Coll did not have a pier built until 1964, and *Lochshiel* and another red boat are seen there in that year, tendering *Claymore*.

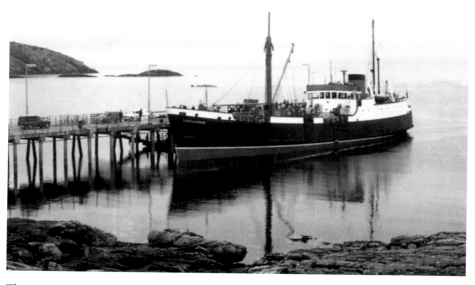

The cargo vessel *Loch Carron* at Coll. Cargo services here ceased in 1975 following the introduction of car ferry services to the island by *Columba* in that year.

On 5 June 1992, a linkspan was opened at Coll, and *Columba* is seen here with the linkspan under construction.

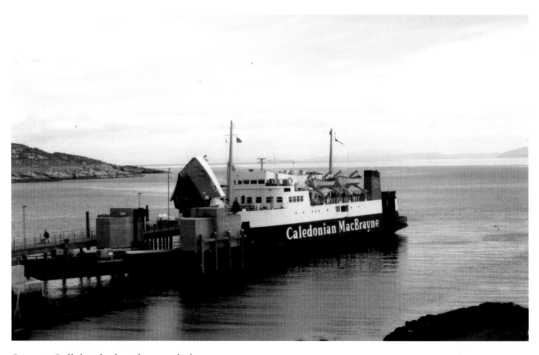

Iona at Coll, berthed at the new linkspan.

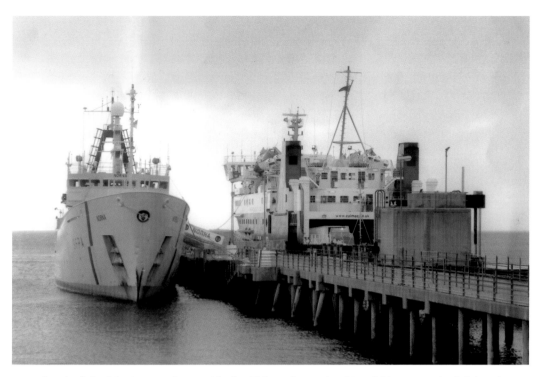

Lord of the Isles is seen there, with the Fishery Protection Vessel *Norna* on the left hand side of the pier.

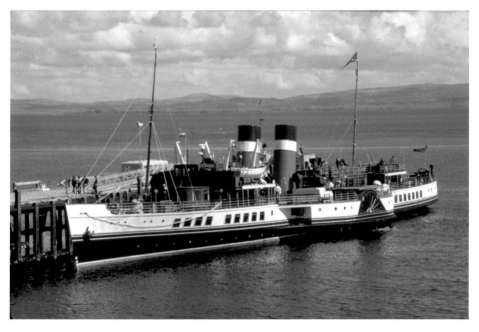

In 2002, *Waverley* made her first visit to Coll on a day trip from Oban, making the first visit there by a paddle steamer since *Pioneer* in 1942.

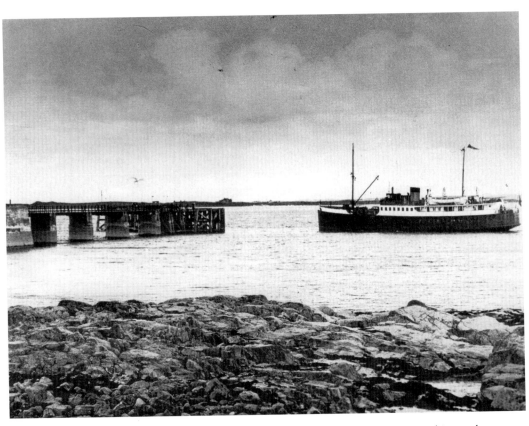

The pier at Scarinish on Tiree, also known as Gott pier, was opened in 1914, and is seen here with *Lochearn* arriving. In 1930, a new Inner Isles mail service was established from Oban to Tobermory, Coll, Tiree, Castlebay and Lochboisdale, which was maintained, initially by *Lochearn* and then from 1955 by *Claymore*, until 1974.

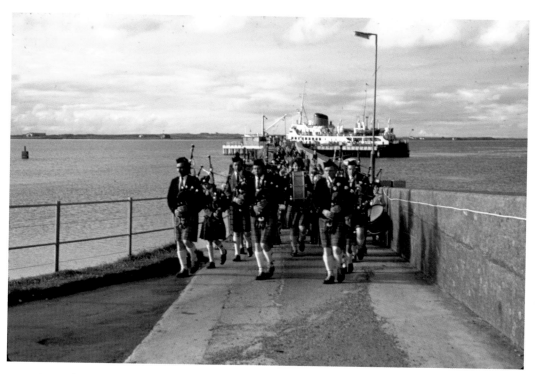

A pipe band marches down the pier from *Claymore* at Tiree in 1974.

Columba berthed at Tiree in 1988, her final year on the route here. She took over the sailings to Coll and Tiree from 1975, serving the islands four times weekly, with a twice-weekly sailing on the Staffa and Iona cruise and a thrice-weekly sailing to Colonsay. These could be combined as a mini-cruise using the cabins on board.

Glen Sannox at Tiree in 1987. She called there in her guise as winter Oban vessel.

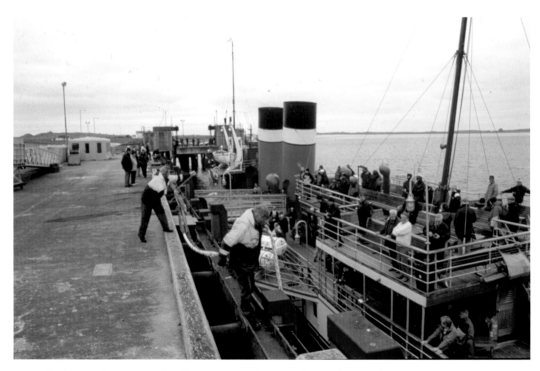

Waverley has made occasional calls at Tiree on day trips from Oban, and is seen there in 2006.

Chapter 3

Piers of the Northern Inner Hebrides (Skye and the Small Isles)

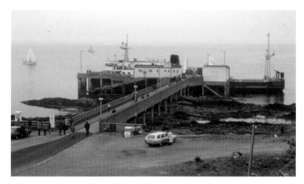

Armadale, at the southern end of the Sleat Peninsula, has been a steamer call since at least the mid-nineteenth century, mainly on the Glasgow to Stornoway service by *Claymore*, *Clansman* and *Clydesdale* and the Oban to Gairloch service by *Gael*. It is mentioned in an 1851 advertisement for *Duntroon Castle,* one of the first advertisements for David Hutcheson & Co. after they took over the West Highland services of G. & J. Burns in that year. From 1930 until 1964 it was a call on the Outer Isles service operated by *Lochmor* and the Portree mail service. The original pier was in too shallow water and was a ferry call. In 1915, a new wooden pier was built and was extended in 1945. The car ferry *Pioneer* is seen there in 15 May 1982 on a Chris Bakalarski charter sailing round Skye from Kyle of Lochalsh with a train connection from the north of England.

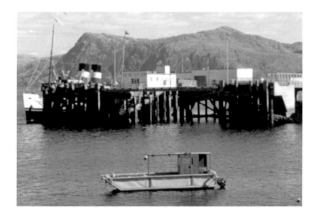

Armadale has had a car ferry service since the 1930s, when the small, privately owned *Road to the Isles* started a service from Mallaig. *Clansman* started a car ferry service on the route in 1964, replaced by *Columba* in 1972, *Bute* in 1975, *Pioneer* in 1979, *Iona* in 1989 and *Lord of the Isles* in 1998. In 1994, a linkspan was added, and since the 1990s *Waverley* has made an annual day trip from Oban to Armadale, extended since 2007 to Inverie. She is seen here at Armadale in 1999.

Lord of the Isles was replaced by *Pioneer* again in 2003 and by the new *Coruisk* later that year, although technical problems with the new ship meant that she did not fully serve the route until the following year. The route remains a summer-only one, with once or twice daily sailings in the winter months by the Small Isles ferry *Lochnevis*. *Coruisk* is seen here with *Waverley* in 2004. Armadale is a notoriously difficult pier to photograph a ship at, especially at a low tide, as seen here with only the tops of the funnels and the masts of *Waverley* visible.

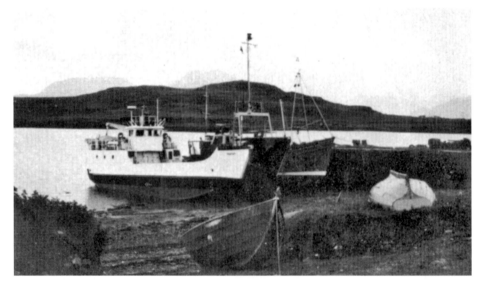

A pier had been built at Isleornsay, half way up the Sleat coast between Armadale and Kyleakin, by 1820, when Robert Napier's *Highland Chieftain* was advertised to sail there from Glasgow on 28 November via the Crinan Canal. It was used by the Stornoway and Gairloch steamers up to *c.* 1914. Unusually, the Island-class car ferry *Raasay* berthed there overnight on 12 June 1977 en route from or to her overhaul.

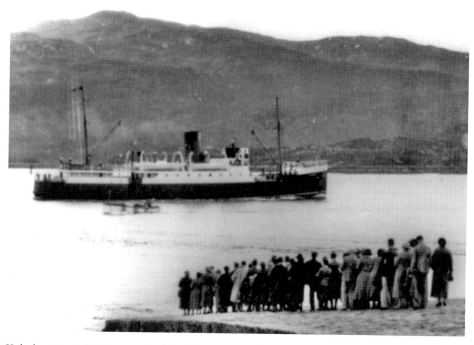

Kylerhea is at the Skye end of the ferry service from Glenelg, and has on occasion been used instead of Glenelg by services between Mallaig and Kyle of Lochalsh. Passengers are seen here on the ferry slip, waiting to be ferried out to the Stornoway to Mallaig steamer *Lochness*, in the 1930s.

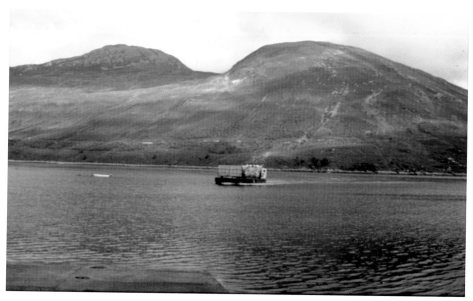

Glenachulish is seen here on the crossing from Kylerhea to Glenelg. *Loch Toscaig* was on a thrice-weekly service from Kyle of Lochalsh to Kylerhea from 1965 until 1972 and a privately owned motorboat ran a service from Kyle to Glenelg in the thirties.

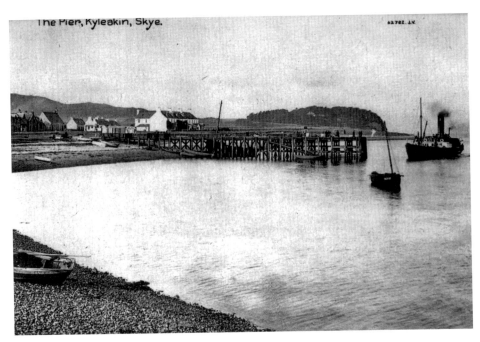

Kyleakin had a long, wooden steamer pier and the Portree mail steamer *Glencoe* is seen off it in the 1908–1912 period. It was used by steamers on the Glasgow to Stornoway and Oban to Gairloch routes prior to 1914.

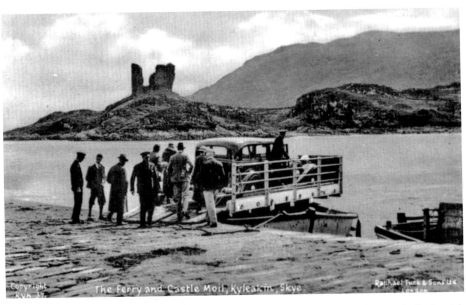

The car ferry service from Kyle to Kyleakin was started in 1918 and its history is dealt with in the section covering Kyle of Lochalsh in *West Highland Piers*. One of the early one-car ferries, *Kyle* or *Kyleakin*, is seen here at Kyleakin in a 1930s postcard view, with a chauffeur with peaked cap getting out of the car while his passengers wait to board. Note Castle Moil in the background.

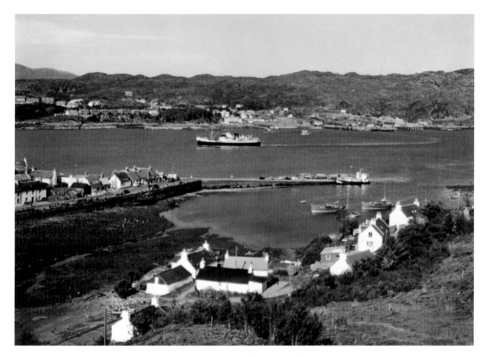

Kyleakin in a 1954 postcard view with *Loch Seaforth* passing, having just left Kyle of Lochalsh. *Lochinvar* is at Kyle pier in the distance and *Loch Toscaig* can just be seen aft of *Loch Seaforth*. Note the three MacBrayne buses on the pier.

Kyleakin slipway from the ferry in 1995, with the Skye Bridge still under construction, Note the two cranes, one each end of the bridge, which opened later that year.

The wooden pier at Broadford was a call by the Portree mail steamer until 1943, and *Glencoe* is seen arriving there in a postcard view.

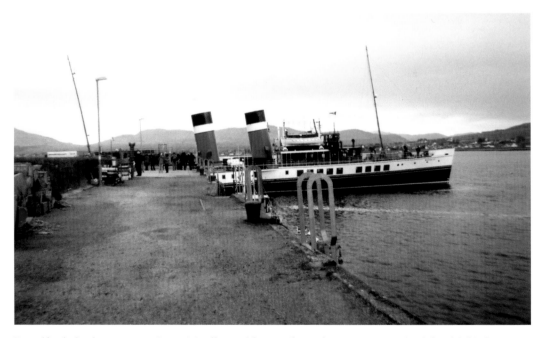

Broadford also has a stone pier, originally used by a railway that ran to quarries inland. This has often been used by *Waverley*, seen there in 2011.

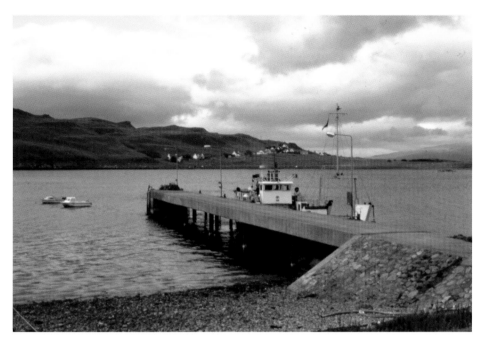

Sconser is not even a village, just a point on the road from Broadford to Portree where a ferry ramp was built for the introduction of a car ferry service to Raasay in 1976. The Island-class ferry *Raasay* is seen here at the ramp in 1994, half-hidden behind the breakwater/small pier.

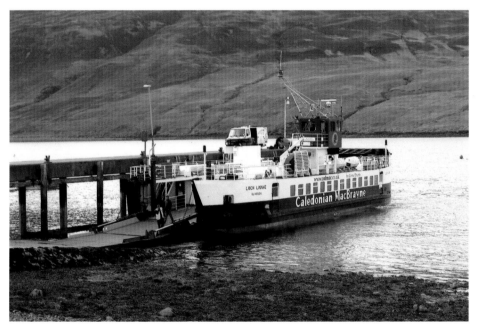

Raasay was replaced by a Loch-class ferry in 1997, and *Loch Linnhe* is seen here, relieving the regular ferry *Loch Striven*, which was away for overhaul.

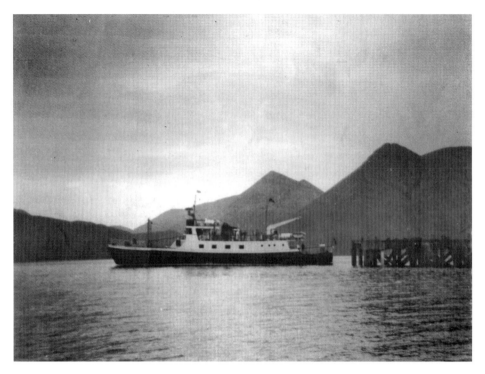

Raasay was a regular call on the Portree mail service, and *Loch Arkaig* is seen there on 11 September 1966. The service ceased in 1975 and a ferry service from Portree was substituted until the Sconser service started the following year.

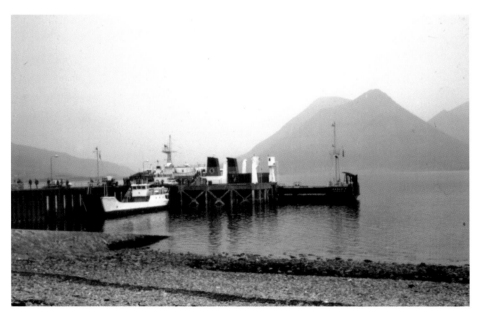

Pioneer at Raasay on the aforementioned Round Skye cruise on 15 May 1982, with *Raasay* at the pier and the Cuillins behind.

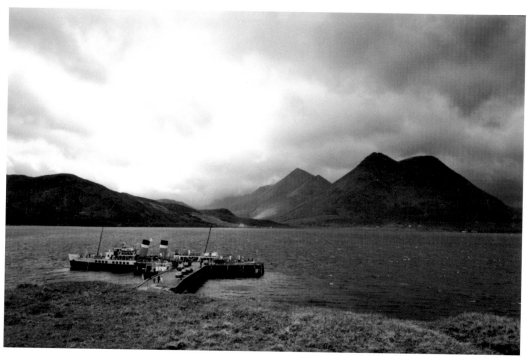

Waverley at the old pier on Raasay in 1989. This pier at Suisnish had been built for the iron ore mine on the island in 1912, a mine which closed on the outbreak of war in 1914 but was later reopened with prisoner of war labour, only to be closed in 1920.

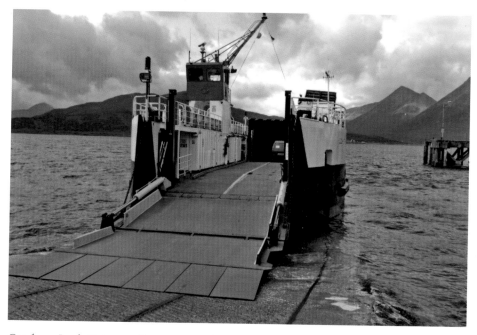

Car ferry *Loch Striven* at Raasay around 2000.

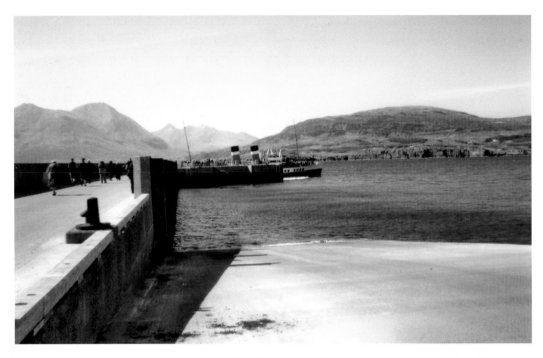

On 17 August 2010, a new pier was opened in Churchtown Bay at Raasay to replace the old one, which was in a poor state of repair. It is seen here with *Waverley* in 2011.

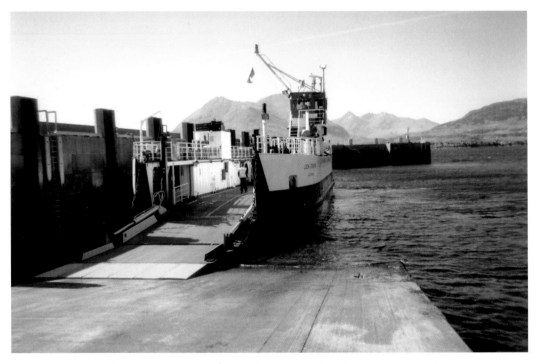

A new slipway was built at the head of the pier for the use of *Loch Striven*, as seen here.

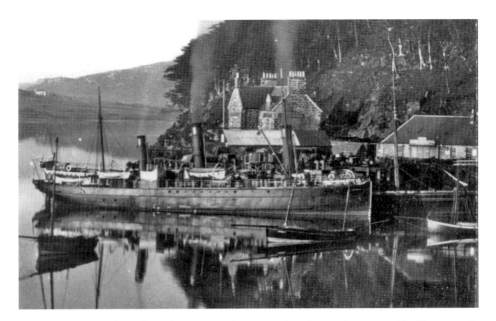

Portree, the capital of Skye, had a fortnightly service from Glasgow with Thomson &
McConnell's Clyde Steam Navigation Company in 1842, and a Glasgow to Portree service
continued, extended to Stornoway after the West Highland services were taken over by
Hutcheson in 1851. Here we see *Lochiel* of 1877 with a two-funnelled paddle steamer,
possibly *Chevalier*, which would be relieving *Gael*, behind her. *Lochiel* was on a thrice-
weekly service from Oban to Tarbert, Lochmaddy and Dunvegan from 1888 until 1909,
and *Gael* was on the Oban–Portree–Gairloch service.

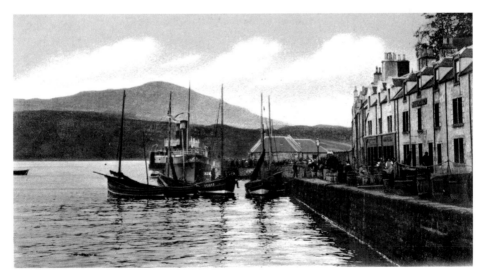

Gael at Portree in an Edwardian postcard view. In 1898 she left Oban at 7 a.m. on Tuesdays,
Thursdays and Saturdays, arriving at Portree at 5:40 p.m. on Tuesdays, when she sailed
via Loch Scavaig, and 3:40 the other two days, arriving at Gairloch at 8:00 or 6:00, and
continuing to Stornoway on Thursdays and Saturdays, returning from there at 11:00 p.m.,
Gairloch at 6:30 the next morning, and Portree at 8:30, arriving at Oban at 5:30 p.m.

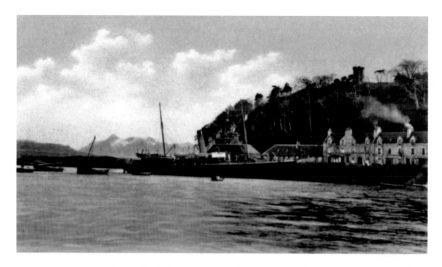

Claymore at Portree. She called there on the Glasgow to Stornoway service, departing Glasgow at 2:00 p.m. on a Thursday and arriving at Portree at 3:00 a.m. on a Saturday, eventually reaching Stornoway via Gairloch at 2:00 p.m. on the Saturday. On the way back she was just listed to leave Stornoway on a Monday morning, with possible calls en route at Lochmaddy, Loch Torridon and/or Staffin Bay, depending on cargo requirements, and leaving Portree at 8:00 p.m., arriving at Glasgow at 7:00 a.m. on a Wednesday. She served the route from her construction in 1881 until she was scrapped in 1931.

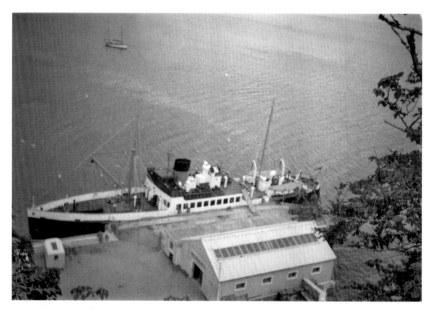

Lochnevis at Portree. She was designed for the mail service from Mallaig and was on it from building in 1934 until 1958, and also on Saturdays in 1959. This image is taken after 1956, when she got a flush hatch to increase her car carrying-capacity. The Portree mail service was maintained, latterly by *Loch Arkaig*, until 17 March 1975, with weekly excursions from Mallaig and Kyle of Lochalsh from 1977 until 1985, initially by *Loch Arkaig*, and from July 1980 by *Lochmor*.

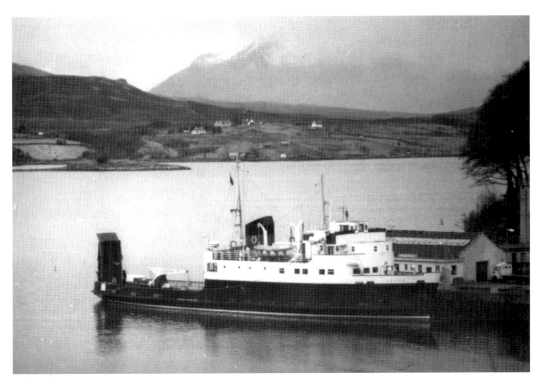

Arran at Portree in 1974, relieving *Loch Arkaig* on the mail service from Mallaig and Kyle.

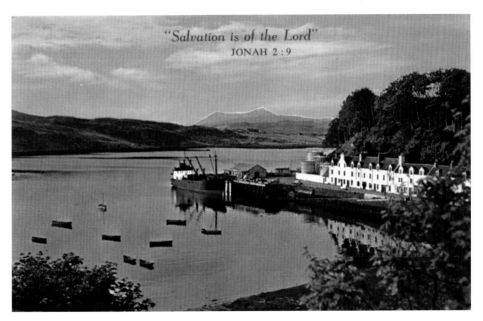

The MacBrayne cargo steamer *Lochdunvegan* at Portree in a postcard view. She was on the Stornoway cargo service, which included a call at Portree from 1950 until it was withdrawn in 1973. After publication, a scripture text has been added to this postcard.

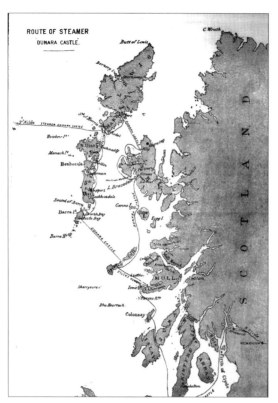

Staffin, on the east coast of the Trotternish peninsula, had occasional calls by the Glasgow to Stornoway steamers. Uig, on the west coast of that peninsula, was a port of call by McCallum Orme's *Dunara Castle*, as were the remainder of the West of Skye calls, as seen in this map of her route. Uig had a 1,300-foot-long pier, built in 1894 and officially opened by King Edward VII in 1902

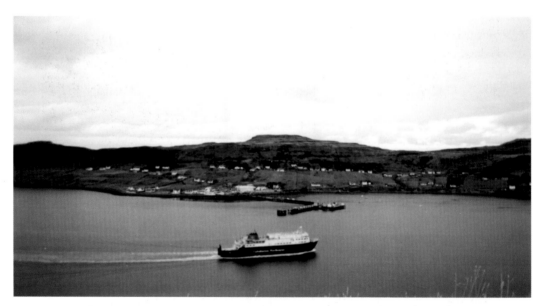

In April 1964, a hoist-loading car ferry service, which replaced the Outer Isles mail service, was introduced on a triangular service from Uig to Tarbert, Harris and Lochmaddy with *Hebrides*. In 1985 a linkspan was installed at Uig and *Hebridean Isles* took over the route, followed in 2000 by the new *Hebrides*, seen here approaching Uig.

Stein, on the west side of the Waternish peninsula, was a port of call for *Dunara Castle*. This was planned as a village by the British Fisheries Association, and designed by Thomas Telford, but the project was not successful and work ceased after only a few houses were built. It is seen here in 1976.

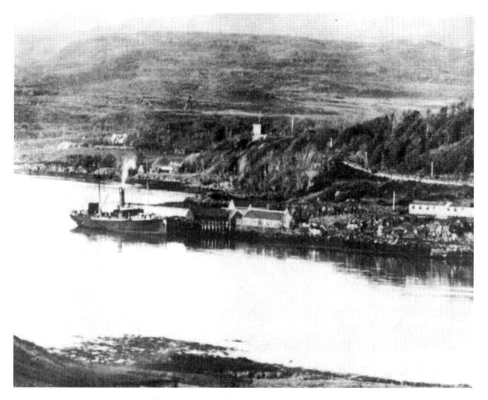

Dunvegan was also a McCallum Orme call and *Hebrides* is seen there with the castle tower visible in the background. It saw a visit by *Waverley* during her Western Isles visit in 1995.

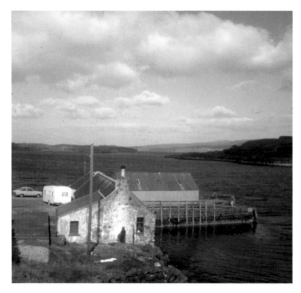

Dunvegan Pier, seen in 1976. MacBrayne's operated a thrice-weekly service from Portree to Dunvegan via Tarbert and Lochmaddy, with calls at Stein and Uig on the return voyage, from 1888 until the First World War, initially by the first *Lochiel* until her grounding in 1907, and from 1908 by *Lapwing*, with *Brigadier* and *Handa* or *Staffa* as relief steamers. Colbost, on the west shore of Loch Dunvegan, was a call for *Hebrides* and *Dunara Castle*.

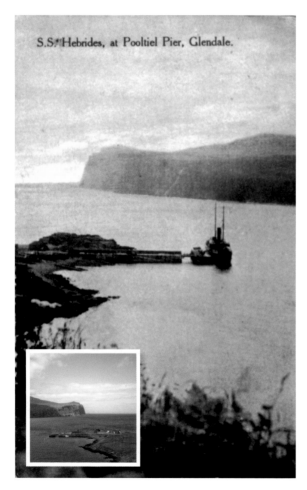

S.S. *Hebrides*, at Pooltiel Pier, Glendale.

Glendale Pier on Loch Pooltiel, seen here with *Hebrides* on a postcard posted in 1925, was mainly a McCallum Orme call. Prior to the reorganisation of the Inner and Outer Isles services in 1930, Dunvegan, Glendale and Struan were part of a service from Oban to Castlebay, Lochboisdale and Lochmaddy, being served on the return from Lochmaddy to Tobermory. This was offered thrice weekly in each direction.

Inset: Glendale Pier in 1976, when it had long ceased to be used by any steamers.

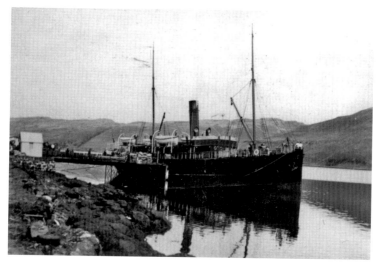

Carbost, at the top of Loch Harport, was a busy call because of the Talisker distillery there and *Hebrides* is seen there *c.* 1912–1913. The crofting community of Portnalong, near the mouth of Loch Bracadale, also had calls latterly by *Hebrides* although it was only founded in 1921, by people dispossessed from Lewis and Harris. Cargo calls at Carbost, Dunvegan and Uig ceased in 1961, and at Loch Pooltiel and Portnalong in 1953.

The very scenic Loch Scavaig was a weekly port of call by *Gael*, seen here in August 1899, up to 1914. It was possible to go ashore by small boat and walk to Loch Coruisk in the heart of the Cuillins. The Glasgow to Stornoway steamers also made calls at Loch Scavaig, as did the McCallum Orme steamers. The first sailing to Loch Scavaig was in 1838 by the City of Glasgow Steam Packet Co.'s *Vulcan*.

It is a long time since any large vessel did Loch Scavaig trips, and now the small excursion boat *Bella Jane* sails from Elgol across Loch Scavaig, as seen here in 1995. Elgol was a port of call of McCallum Orme's *Hebrides* in the 1930s.

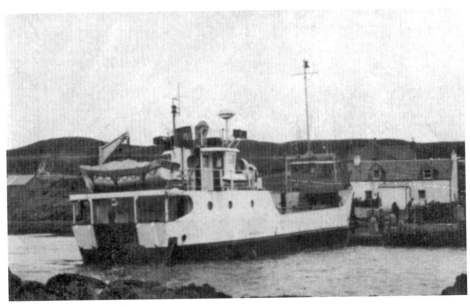

The Small Isles of Muck, Eigg, Rum, previously spelt Rhum, and Canna have been served from Mallaig since 1964 by *Loch Arkaig*, from 1979 by *Lochmor* and from 2000 by *Lochnevis* respectively. All except Canna were ferry calls until recent years. Prior to 1964 they were part of the Outer Islands mail steamer itinerary, apart from Muck, which was not served by MacBrayne steamers prior to the sixties, and only had a weekly call in the late sixties and into the seventies. Muck is an agricultural island with a population of only thirty and the Island-class car ferry *Eigg* is seen there in October 1978 on a special cattle run.

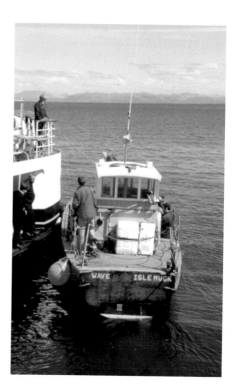

In 1999, the island-owned Muck ferry boat *Wave* tendered *Waverley* to take passengers ashore for a wedding. This was a unique day for Muck with three vessels calling, *Lochmor* on the regular run from Mallaig and *Bruernish* on a special sailing from Oban with a bull to serve the island farm's herd of cows.

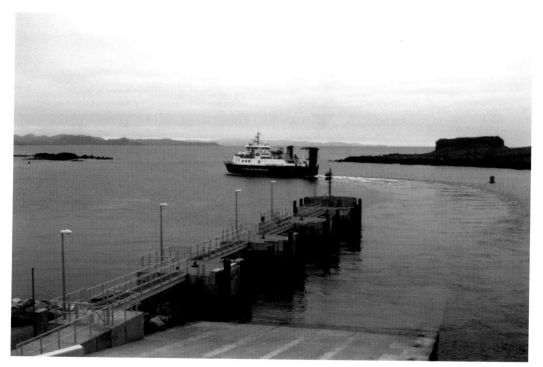

A slipway was built at Port Mor, Muck in 2005 to allow vehicles to be disembarked from *Lochnevis*, seen here departing from the slipway, and the ferry ceased then.

Eigg was served by a MacBrayne ferry boat linking with the Small Isles vessel from Mallaig. *Ulva* is seen here at her island berth in the 1980s. Prior to the introduction of the Outer Isles service in the 1930s, Eigg was served by a weekly call by the Glasgow to Stornoway steamer *Claymore*, and, prior to 1914, by thrice-weekly calls by the Oban to Gairloch steamer *Gael*.

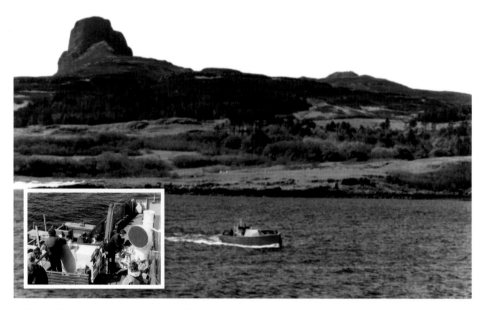

Ulva on her way out to meet *Lochmor* with the distinctive Sgurr of Eigg mountain in the background.

Inset: Ulva moored alongside *Lochmor* and disembarking passengers.

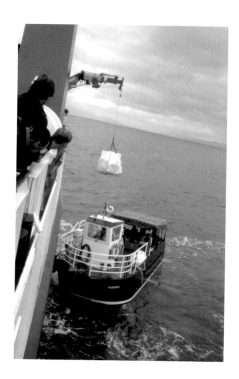

In December 2000, *Ulva*'s wooden hull had deteriorated and she was replaced by *Laig Bay*, seen here in 2002 with a mailbag being lowered from *Lochnevis*.

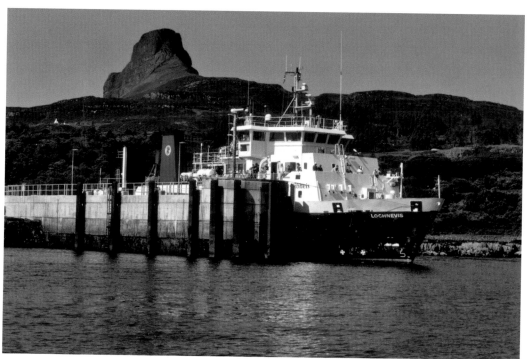

In 2004, a pier was completed at Eigg and *Lochnevis* is seen berthed there. Eigg has been owned by the islanders since 1997 and is one of the few small islands to be prospering, with around ninety-five inhabitants in 2010 and an increasing school roll.

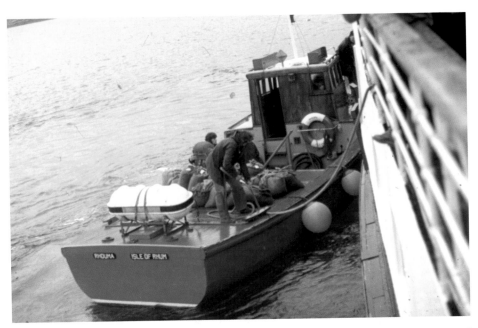

Rum had its own ferry boat, *Rhouma*, seen here in 1977 alongside *Loch Arkaig*. Rum and Canna were served prior to the 1930s by the Oban–Outer Isles–Dunvegan service on the return from Dunvegan. Rum was known as Rhum from the 1890s until 1991, the spelling having been invented by the owner, Sir George Bullough, because he did not want to be known as the Laird of Rum. In 1957 the island was purchased from his widow by the Nature Conservancy Council and is now owned by Scottish Natural Heritage. It has only around thirty inhabitants.

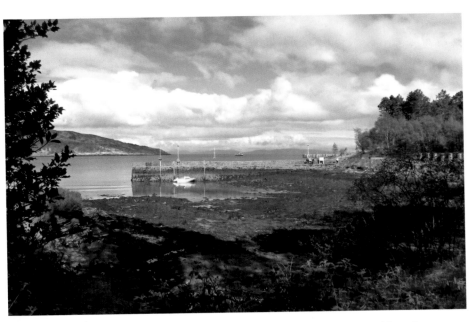

The old stone pier at Loch Scresort on Rum, which would have been used by *Rhouma*, on 23 April 2011. Note *Waverley* anchored in the background.

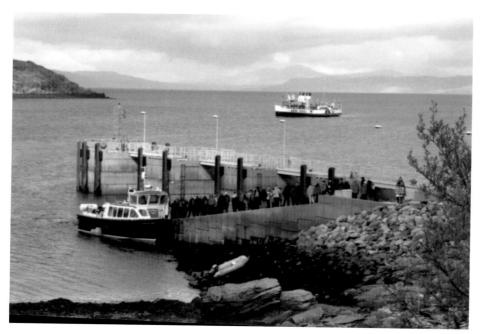

A new pier was opened on Rum by *Lochnevis* in December 2003. It is seen here on 23 April 2011 with *Ullin of Staffa* tendering *Waverley* on a unique call on a day trip from Oban.

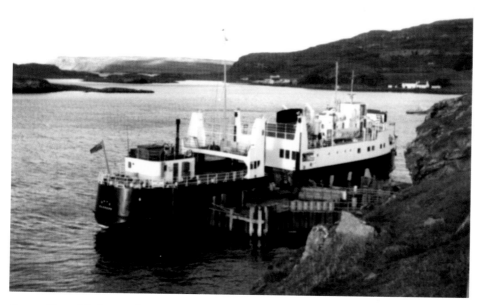

Canna Pier with the car ferry *Bute*, which was relieving the regular vessel *Loch Arkaig* for overhaul in 1977 or 1978. Canna has been owned by the National Trust for Scotland since 1992. It only has around twenty inhabitants, although there have been recent efforts to attract more people to live there.

Lochmor discharging cargo at Canna. In 2006, a new slipway was opened adjacent to the pier to enable *Lochnevis* to unload vehicles.

North of Canna, the island of Soay had a steamer service at one time with calls by *Dunara Castle*, and in 1948 until 1953, when the last inhabitants left, the Outer Isles steamer called, with a ferry from Soay connecting with it at Loch Scavaig in the latter year.

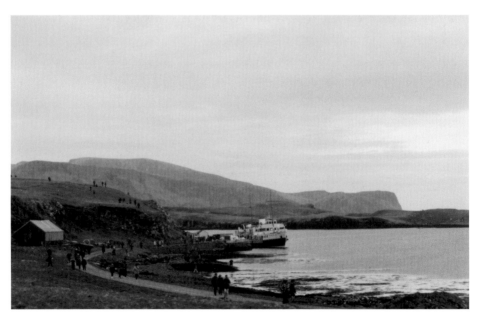

In 2000, *Balmoral*, Britain's most travelled coastal excursion vessel, made a unique call at Canna.

Chapter 4

Piers of the Western Isles

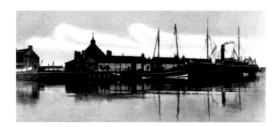

The first steamer recorded as operating to Stornoway was *Mary Jane* in 1846, later well known as *Glencoe*, which was locally owned by James Matheson, and sailed to Lochinver and Portree on alternate Mondays. Three years later the same owner's *Marquis of Stafford* sailed to Poolewe, replacing *Mary Jane*, which was sold to the Glasgow & Lochfine (sic) Steam Packet Co. in 1851. In 1853, the first *Chevalier* was on the Glasgow to Stornoway service for David Hutcheson & Co., but was wrecked on 24 November the following year, to be replaced by the paddle steamer *Clansman*, which operated the service along with *Stork* from 1858, until she was sold in 1861. The paddle *Clansman* ran aground on Sanda on 21 July 1869 and was replaced by a second ship of that name, a screw steamer, in 1870. The first Hutcheson screw steamer, *Fingal*, replaced *Stork* in 1861, but was sold for blockade running after only 4 months' service. *Clydesdale* replaced her on the route in 1862 and *Claymore*, seen here at Stornoway in a postcard view, was on the route from 1881 until her withdrawal in 1930. This route was sold as a scenic cruise from Glasgow.

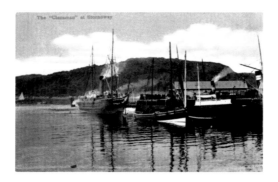

Claymore's consort *Clansman* arriving at Stornoway in a postcard view, posted in 1909, the year she was withdrawn and replaced by the new *Chieftain*. The normal practice was for *Clansman* to leave Glasgow on a Monday and *Claymore* on a Thursday, arriving at midnight on a Wednesday via Lochinver and 2:00 p.m. on a Saturday via Gairloch respectively in the 1898 timetable. *Chieftain* was sold in 1919 and the route was worked by *Claymore* for a further eleven years, then by *Lochbroom* and by *Lochgarry* from 1937. It became purely a cargo service with *Lochgorm* from 1940, *Lochdunvegan* from 1951 and *Loch Carron* from 1973 until the ending of MacBrayne cargo steamer services in 1975.

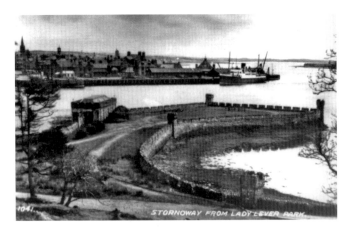

The Highland Railway Company operated a service from Strome Ferry to Stornoway in the summers of 1870 and 1871. From 1871 until 1885 a mail steamer operated from Ullapool to Stornoway, replacing the sailing packets that previously sailed twice weekly to Poolewe. This was the PS *Ondine* of 1847, built as a Dover to Calais mail steamer, sold in 1855 to the *Morning Herald* for an express courier service from Calais, bringing news items from Continental Europe to the presses faster than by the mail service, and then owned by Sir James Matheson, and was replaced in 1881 by MacBrayne's first *Lochiel*, now sailing from Strome Ferry. She was replaced by *Clydesdale* from 1886, running from Kyle on the opening of the railway in 1897. The paddle steamers *Glendale* and *Gael* made an appearance on the service, which was extended to start from Mallaig when the railway opened there in 1901 and in 1904 the new *Sheila* took over the service until she was wrecked in the early morning of 1 January 1927 near the mouth of Loch Torridon. She was replaced by the new *Lochness* in 1929, seen here at Stornoway in a postcard view.

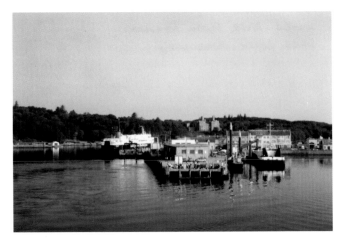

In December 1947, the new *Loch Seaforth* replaced *Lochness* on the mail service, and was herself replaced in 1972 by *Iona*. The route was transferred back to start from Ullapool from March 1973, by which time linkspans had been installed at both ports, and *Clansman*, newly converted to drive-through, took over two months later. She was replaced the following year by the much larger Norwegian-built *Suilven*, which served the route until 1995, which is seen here laid up in the inner berth at Stornoway after her final sailing.

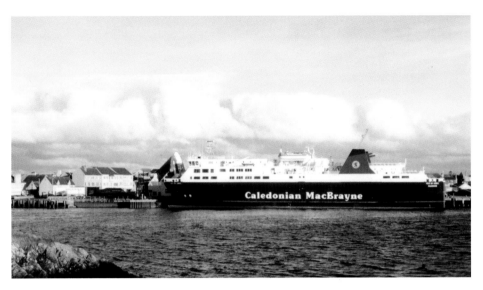

Suilven was replaced in 1995 by the purpose-built *Isle of Lewis*, seen here at the old MacBrayne pier in Stornoway.

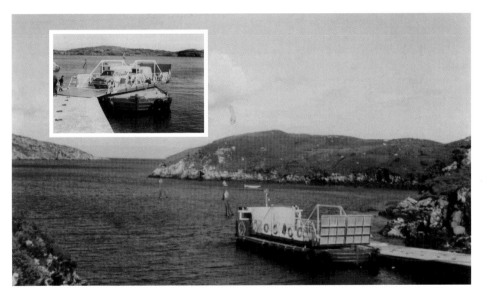

The island of Scalpay was served from the 1930s by the Outer Islands mail service, normally maintained by *Lochmor* and by small boats running to Tarbert. In 1964 the Outer Islands service was withdrawn on the introduction of the car ferry service from Uig to Tarbert, and in the following year the timber-hulled former Ballachulish turntable car ferry *Maid of Glencoe* was purchased and renamed *Scalpay* for a car ferry service from Carnach, also known as Kyles Scalpay, on the mainland to Port na Geiltean on Scalpay. She is seen here at Port na Geiltean on 6 July 1968. She was replaced in 1971 by the former Kyle–Kyleakin ferry *Lochalsh II*, later renamed *Scalpay*, which was herself replaced by the first Island-class ferry *Kilbrannan* in 1977, then *Canna* in 1990 and *Rhum* early in 1997. In December 1997 a bridge replaced the crossing.

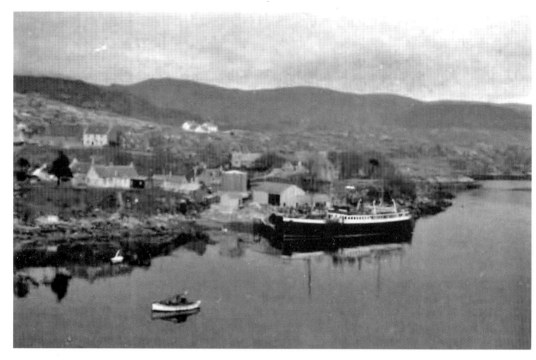

Lochmor berthed at Tarbert on 7 April 1964, her penultimate week on the Outer Isles service she had served since building in 1930.

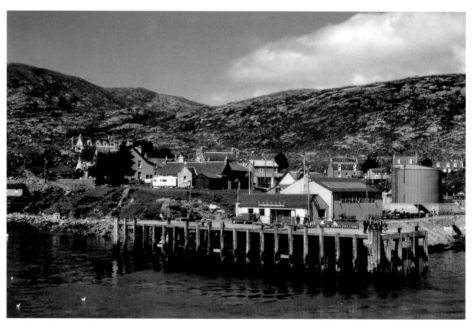

The pier and pier buildings at Tarbert in 1967. The Outer Isles service which *Lochmor* had undertaken was replaced by the hoist-loading car ferry service with *Hebrides* from Uig and Lochmaddy in 1964.

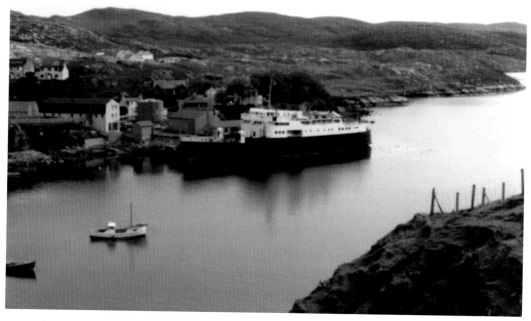

The car ferry *Hebrides* of 1964 at Tarbert.

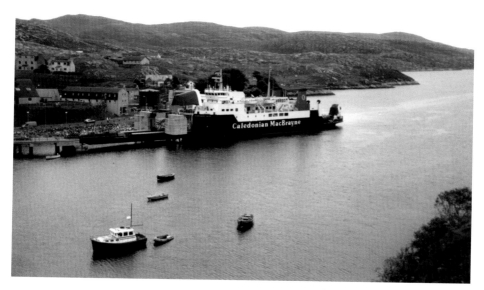

In 1986, a linkspan was built at Tarbert and the new *Hebridean Isles*, seen here, took over the route. When the Sound of Harris route was opened in 1996, the vast majority of Tarbert to Lochmaddy sailings ceased, and in 2000 the new *Hebrides* replaced *Hebridean Isles*.

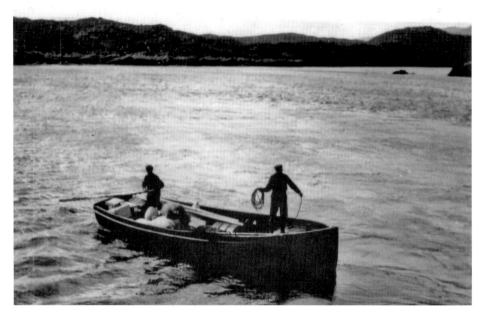

The Outer Isles service made a weekly ferry call at Stockinish in Harris. MacBrayne's rowing boat *Dumb Barge No. 2* tendered *Lochmor*, as seen here on 8 September 1948. Note the single oar at the stern. Calls at Stockinish ceased in the mid-1950s.

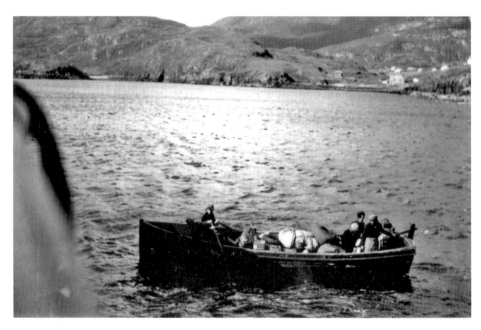

Dunara Castle made a ferry call at Finsbay, between Stockinish and Rodel. Rodel, also on Harris, was a MacBrayne ferry call, and the MacBrayne rowing boat *Dumb Barge No. 1* is seen there, also on 8 September 1948. She remained in service until *c.* 1954 and Duckworth and Langmuir state that she may latterly have been renamed *Rodel*. She was replaced by the motor boats *Garry*, *Glenelg* and *Kilchoan* respectively until the closure of the service in 1964.

Rodel harbour in 1974. Rodel
dates back to the 1780s and the
Rodel Hotel is probably the oldest
continuously inhabited house in the
Outer Hebrides.

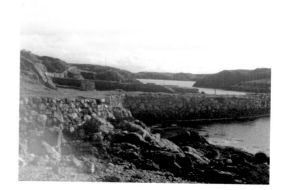

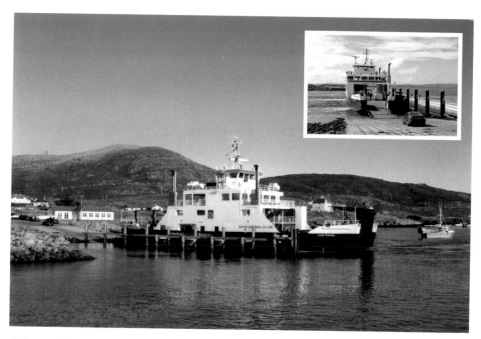

Obbe, at the south of Harris, had been a call for *Dunara Castle*. In 1920, it was renamed
Leverburgh, after the island had been purchased by Lord Leverhulme, and a new fishing
harbour was built and a new village planned. He died in 1925 and the project was abandoned.
In 1996, Caledonian MacBrayne opened a new service from here to Otternish in North Uist
with the new water-jet propelled ferry *Loch Brusdha*. She had water jets rather than Voith-
Schneider propellers because the route is very winding and treacherous with a lot of shallow
water. In December 1998, on completion of a causeway to Berneray, the southern terminal
moved there. By 2003, the increasing popularity of the route meant that the eighteen-car *Loch
Brusdha* had to be replaced by the thirty-two-car *Loch Portain*, seen here at Leverburgh.

Inset: Loch Portain embarking cars at Leverburgh.

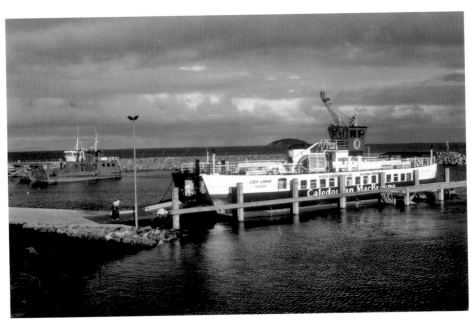

Loch Linnhe, on relief duty at Berneray, with the Western Isles Council-owned ferries *Eilean Na h-Oige* and *Eilean Bhearneraigh*, redundant after building of the causeways to Berneray and Eriskay in 1999 and 2001 respectively, laid up in the background.

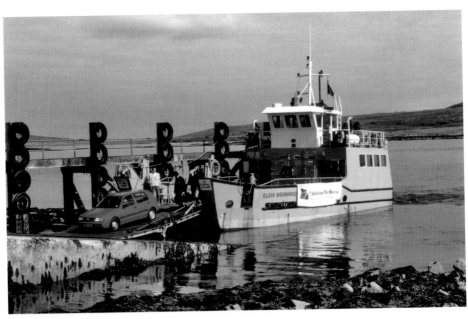

Eilean Bhearneraigh disembarking cars from Berneray at Otternish in August 1996. She was on charter to Caledonian MacBrayne, who took the Berneray service over from the council in that summer. She had been built in 1982 by George Brown (Marine) Ltd of Greenock. Prior to the car ferry service, a passenger ferry service had operated from nearby Newton Ferry to Berneray with small boats.

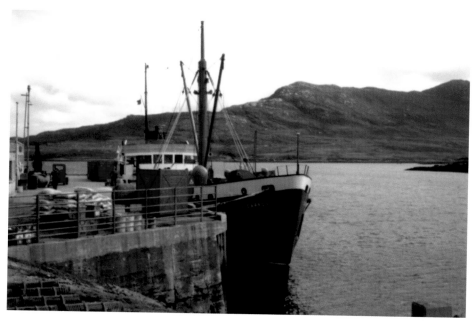

Lochmaddy is the main settlement in North Uist. The first historical mention of it is as a base for pirates in 1618 and a quay had been built by the early eighteenth century. It was a call on the old Outer Isles service from Oban, one way via Castlebay and Lochboisdale and the other via Dunvegan and the west of Skye, operated thrice weekly in each direction by *Staffa*, formerly *Adela*, and *Flowerdale* from 1888 until the early twentieth century, and by the Portree–Tarbert–Dunvegan service prior to the First World War, and by the Outer Isles service from 1930. In 1964, a car ferry service started from Uig. It was also a call for MacBrayne cargo ships, and *Loch Carron* is seen here in this shot.

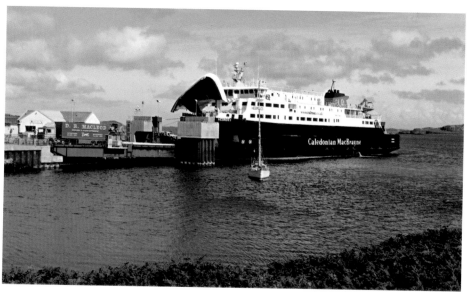

A ro-ro linkspan was installed in 1986, seen here with the current *Hebrides*.

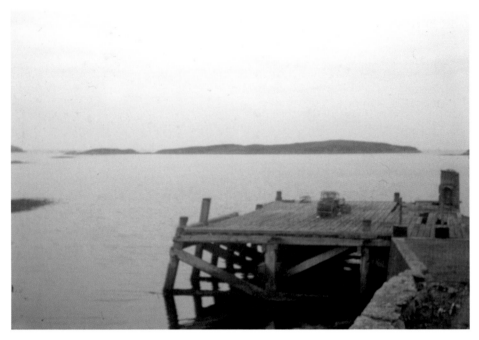

McCallum Orme's *Hebrides* and *Dunara Castle* also called at Loch Eport, Kallin and Scotvin in South Uist. In 1896, a pier was built at Petersport in Benbecula, but it had no road access, being on the island of Eilean na Cille, which was not connected to Benbecula by causeway. Access by sea was poor and it was only served by MacBrayne streamers in 1910. Benbecula was connected to North and South Uist by fords, which were replaced by causeways in 1960 and 1942 respectively. Petersport pier is seen here in 1977.

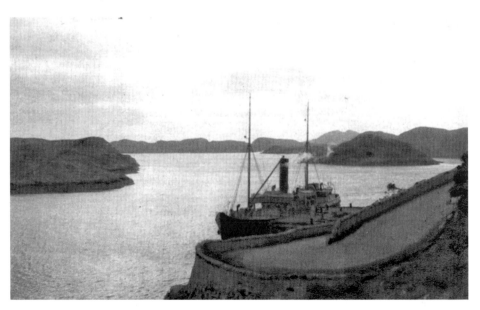

Hebrides and *Dunara Castle* had a ferry call at Carnan, near the ford to Benbecula, and the former called at Loch Skipport, where she is seen here, in the north of South Uist.

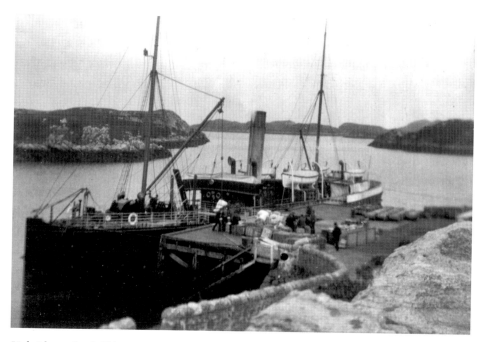

Hebrides at Loch Skipport *c.* 1912–1914, one of a number of calls, some at piers and some by ferry, made by the McCallum Orme steamer in the Uists.

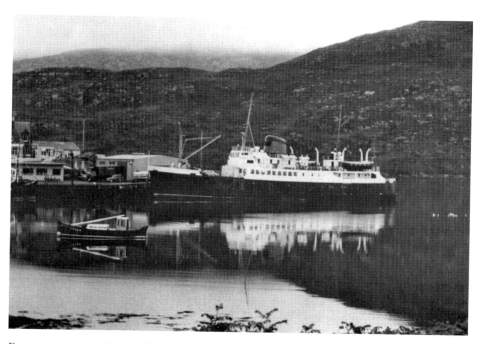

From 1919 a new Inner Islands mail service was started from Oban via Coll, Tiree, and Castlebay to Lochboisdale, initially with *Cygnet*, from 1930 with *Lochearn*, and from 1955 until late 1971 by *Claymore*, seen here at Lochboisdale. She was replaced by *Loch Seaforth* until her sinking in Gunna Sound in March 1973.

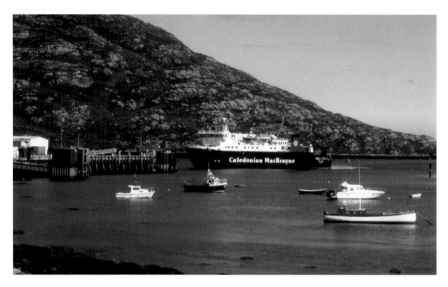

From 1967 to 1974 the 1964 *Clansman* offered an overnight car ferry service from Mallaig to Lochboisdale. In 1974 a linkspan was built at Lochboisdale and a car ferry service to Barra and Lochboisdale was started from Oban with *Iona*, with Coll and Tiree served by a different ship from Oban. *Iona* was replaced by the car ferry *Claymore* in 1979, and by *Lord of the Isles*, seen here approaching the pier at Lochboisdale, in 1989. *Lord of the Isles* was herself replaced by the new *Clansman* in 2002. The Mallaig service was restarted with *Pioneer* in 1988, and was offered by *Iona* from later that year until 1990, when it was stopped because Mallaig had not yet got a linkspan. She operated it again from 1994 to 1998 with *Lord of the Isles* taking over from 1998 until 2001.

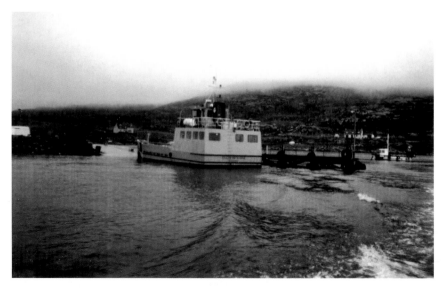

There was a local authority-run ferry service from Ludag, also spelt Ludaig, to Eriskay from 1980 until the causeway was completed in 2001 with *Eilean Na h'Oige*, seen here at Ludag on 5 June 1998.

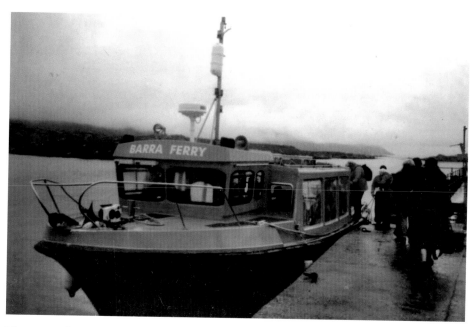

There was also a passenger ferry service across the Sound of Barra from Ludag to Eoligarry. *Fiona Maria*, seen here, was the craft on the service on 5 June 1998.

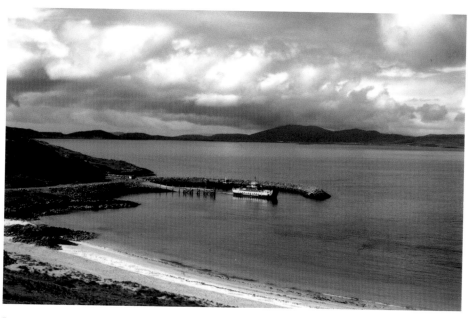

In 2003, Caledonian MacBrayne opened a car ferry service across the Sound of Barra, thus completing a route right down the length of the Western Isles. *Loch Brusdha*, seen here departing Eriskay on 5 September 2003, was the first full-time vessel on the service, which had been inaugurated by *Loch Linnhe* on 4 April that year, handing over to *Loch Brusdha* on 7 June.

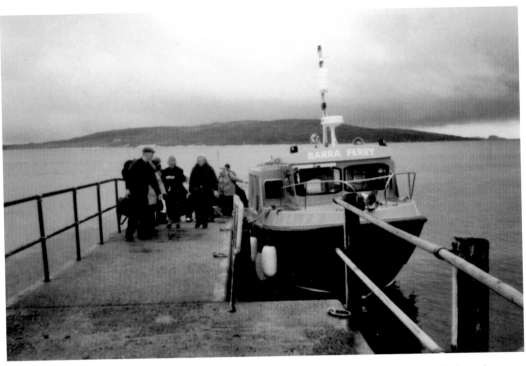

Fiona Maria at Eoligarry, Barra on 9 June 1998. In addition to offering a service to Ludag, she also sailed to Eriskay.

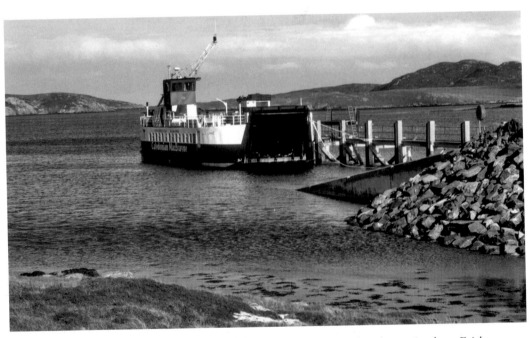

Loch Linnhe arriving at Ard Mhor, Barra, on 3 May 2003, a month after the service from Eriskay commenced.

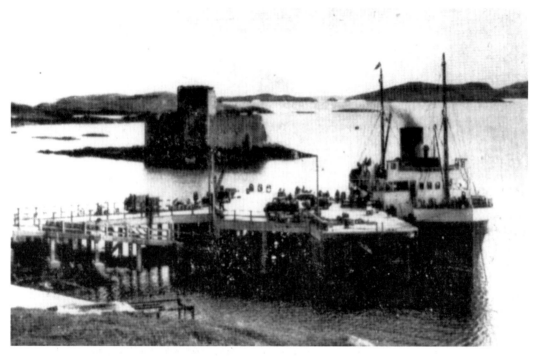

The McCallum Orme steamers *Hebrides* and *Dunara Castle* called at Northbay on the east of Barra but the vast majority of calls have been at Castlebay, the island capital, and the main settlement. Kismuil Castle, the seat of the McNeils of Barra, restored as a family home from 1938 until 1970, is in the bay, hence the name. MacBrayne's *Lochness* is at the pier during her brief spell on the Inner Isles service from 1947 until 1955.

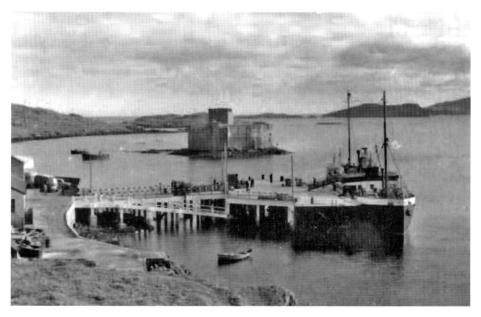

Lochearn at Castlebay on 6 April 1964.

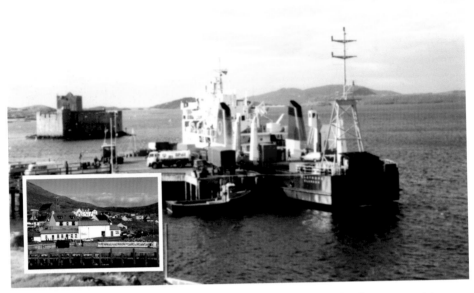

A car ferry service to Castlebay started in 1971 from Mallaig with *Clansman*, and in 1974 from Oban with *Iona*. *Claymore*, seen here, was on the run from 1979 until 1989.

Inset: Castlebay Pier buildings in the 1980s.

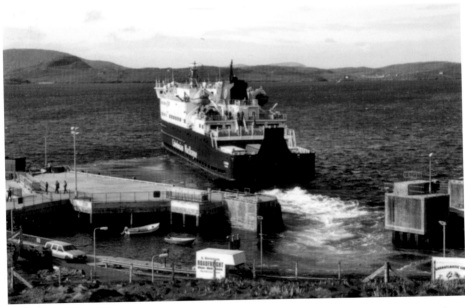

A linkspan was added at Castlebay in 1989 and *Clansman*, which took over the route from Oban in 1998, has just left the pier. There was a passenger service by a small boat from Castlebay to Vatersay until a causeway was opened there in 1991.

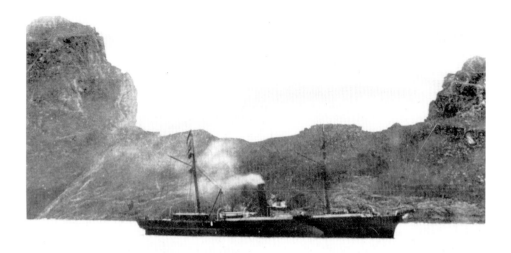

Both *Hebrides* and *Dunara Castle* offered regular cruises to St Kilda, out in the Atlantic, serving the island population until the island was evacuated in 1930. Each sailed every ten days from Glasgow to the Western Isles and Skye, and between May and September 1938 there were a total of nine extended trips to St Kilda between them, also four to Loch Roag, on the west of Lewis, by *Dunara Castle*, six trips round the Isle of Skye by *Hebrides* and a total of seven trips to the Skye lochs and Iona between the two steamers. MacBrayne also offered cruises to St Kilda by the 1862 *Clydesdale*, seen here between 1889 and her loss in January 1905.

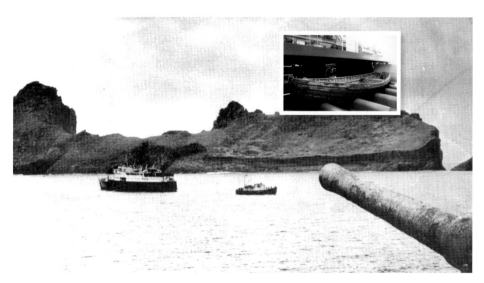

On 5–6 May 1979, *Columba* offered a special cruise to St Kilda from Gourock. In her present incarnation as the luxury cruise ship *Hebridean Princess* she regularly calls at St Kilda, weather permitting.

Inset: Amazingly, the jolly-boat from *Dunara Castle*, which would have been used to ferry passengers ashore at St Kilda, has survived and is now on display in the new Riverside Museum in Glasgow.

Piers List

Southern Inner
Hebrides (Islay,
Jura, etc.)
(pp. 5–24)

Gigha South pier
Gigha ferry slip
Gigha North End
Port Ellen
Port Askaig
Bonahaven/
Buinnahabhan
Caol Ila
Ardbeg
Bowmore
Bruichladdich
Port Charlotte
Feolin
Craighouse
Ardlussa
Colonsay
Scarba
Blackmillbay
Toberonochy
Cuan Ferry
Easdale

Central Inner
Hebrides (Mull,
Tiree, etc.)
(pp. 25–54)

Duart Castle

Craignure
Salen
Tobermory
Tobermory slipway
Calgary
Tavool
Tiroran
Croggan
Bunessan
Fionnphort
Carsaig/Pennyghael
Ulva
Gometra
Staffa
Iona
Coll
Tiree
Lismore

Northern Inner
Hebrides (Skye and
the Small Isles)
(pp. 55–78)

Kilmaluaig
Armadale
Isleornsay
Kylerhea
Kyleakin
Kyleakin Pier
Broadford
Sconser
Raasay

Portree
Staffin
Uig
Stein
Dunvegan
Colbost
Glendale (Loch
Pooltiel)
Struan (Loch
Bracadale)
Portnalong
Carbost
Elgol
Loch Scavaig
Eigg
Muck
Rum
Canna
Soay

The Western Isles
(pp. 79–95)

Stornoway
Kyles Scalpay
Scalpay
Tarbert Harris
Stockinish
Finsbay
Rodel
Obbe/Leverburgh
Loch Roag
Berneray

Otternish
Lochmaddy
Loch Eport
Petersport
Kallin/Scotvin
Carnan
Loch Skipport
Lochboisdale
Ludaig
Eriskay
Ard Mhor
Barra (Northbay)
Eoligarry
Castlebay
Vatersay
St Kilda